Supplies

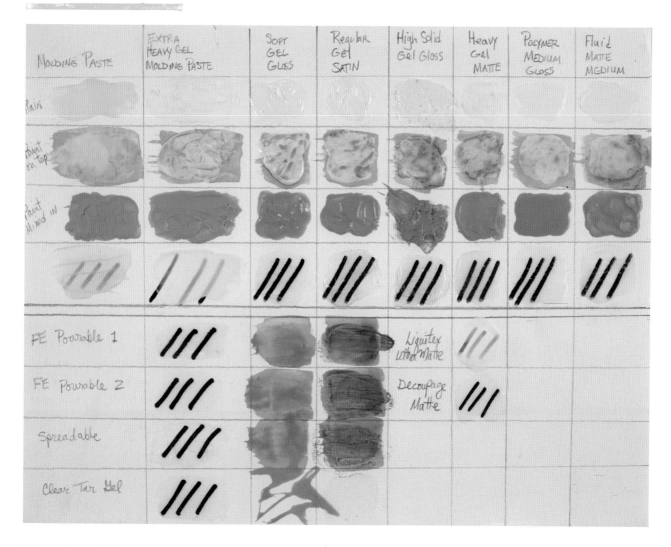

Viscosity and Sheen

Viscosity has to do with the thickness or fluidity of the product, and sheen not only means glossy or matte, but how it can diffuse or sharpen layers. This chart is a rudimentary example of how some of these different pastes look with and without paint.

As a general rule pastes are more opaque while gels are glossy to matte. The gels can come in many different viscosities ranging from soft to extra-heavy. They also come in matte to gloss. Mediums are more fluid and come in gloss and matte. The main thing to remember is the acrylics are white when wet but dry clear except for the pastes.

The first row shows the product alone and the second row shows it with paint applied on the surface after the product has dried. The third row demonstrates how it looks when the paint is mixed into the product, and the fourth row shows the opacity of each product. You can see how opaque some of the pastes are, and if applied thickly they would obscure what is below them.

The lower portion of the chart shows various faux encaustic recipes and other products. You can always adjust the sheen of your mixture by adding more or less of matte or gloss. Experiment with your own mixtures. When building a lot of layers, it is best to work with gloss and finish with one or two final matte layers. My painting may have up to twenty layers, and if they were all matte it would completely obscure the early layers. I may work with different sheens on the same surface and then unify them at the end with a spray varnish.

TEST STRIPS

MAGENTA

GLAZE MAGENTA

COBALT TEAL

GLAZE TEAL

YELLOW OCHRE

GLAZE OCH

VAT ORANGE

GLAZE ORANGE

BLACK

GLAZE BLACK

Paints

I work with fluid or soft body acrylic paints because I am painting in thin layers, and I find this is the most logical way to work. When needed, I can make the paint act like a heavy body paint by mixing it with gel.

Tools

I use inexpensive synthetic soft brushes. I mostly use a plastic palette knife that is trowel shaped. Silicone tools are wonderful to work with too. My favorite tool is my hand, using gloves or a barrier cream for protection. Everyday items like wood skewers, plastic key cards, found objects and deli papers are great for moving paint.

Faux Encaustic Spreadable Acrylic Medium Recipe

Mix together soft gel gloss, heavy gel matte and water. Begin with equal parts of gel and add water in small amounts at a time. Using a palette knife, stir the mixture until you have a soft, spreadable consistency. Change the viscosity by adding water or alter the sheen by adding more gloss gel or more matte gel. I suggest you make a sample board along with your recipes. These are invaluable for future mixtures. Apply mixture over a swatch of light color and let it dry to see what the recipe looks like.

Color Chart

Paints can be opaque or transparent. You can always change that by adding mediums. To make an opaque paint more transparent, mix it into a gloss medium or gel. To make a transparent paint more opaque, mix in either white or to keep the color from shifting, mix it into light molding paste.

The color sample chart shows the opacity of the paints, using the black lines. The first column shows the paint as it comes out of the bottle, and the second column demonstrates how the paints are made more transparent by making them into a glaze (mixing the paint with polymer medium gloss).

The first column also shows the paint with extra-heavy gel molding paste applied thinly over the paint and regular gel semigloss. The right-hand column shows the glazes with various faux encaustic recipes applied on top.

Supports

I am working for the most part on Ampersand Artist panels.

Claybord: Claybord is super smooth and absorbent. Its surface is a kaolin clay ground formula similar to the clay gesso grounds used during the Renaissance. Work the surface by thinly applying paint or ink, then remove it, reapply it, even scratch through it to add contrast, texture and fine details. I like to spray water on it, rub it in and add a bit more water to create a surface good for acrylic painting.

Encausticbord: The Encausticbord ground has been specially formulated to provide superb adhesion between the paint and the surface. The ground is formulated with a very high solids to acrylic binder ratio, which results in a very porous and absorbent surface. I love this surface for acrylic and mixed media painting. It has great adhesion and can take about whatever I throw at it.

Gessobord: There are so many different grades of panels out there and some simply do not work well. I have seen paintings just rub off from inexpensive boards. These gesso panels are super absorbent, not slick like others.

Aquabord: For best results, it's a good idea to first "flush out" the surface of the panel with water using a large flat watercolor brush to release trapped air. Once the surface is slightly damp, it is ready to use. Rewetting may be needed as you work. Note that heavy water applications may release more air. Use a blow dryer to dry and also to dissipate air if needed.

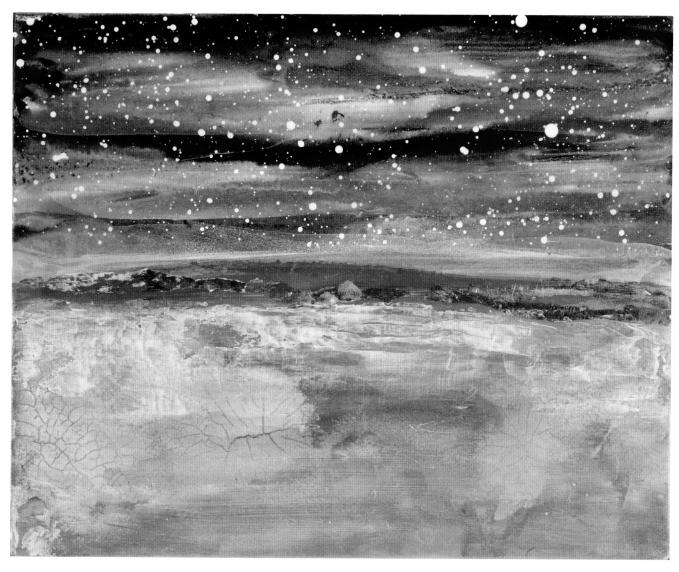

Born on the Solstice
8" × 10" (20cm × 25cm)

Materials list

MEDIUMS
extra-heavy gel molding paste, heavy gel matte, soft gel gloss

MISC.
Ampersand Gessobord, mixing containers, mixing cups, palette knife, water

Making a Mix

Any mixture of gloss and matte gels may be combined to produce a spreadable mixture. Gels come in soft, regular and heavy viscosities. Create your own perfect mixture gel to get your favorite texture.

When to Use Spreadable

• When you have a lot of texture in the form of peaks and valleys.

• When you wish to add texture to your encaustic layer. (Your knife will leave ridges.)

1. **Spreadable** Mediums

This great recipe mimics the look of wax. You may add a tiny drop of Transparent Yellow Iron Oxide if you wish, but I prefer the white look. I may add glazes later to adjust the color. I find I have more control over the look of the layers by adding glazes rather than mixing in colors.

1 Mix the Recipe
Create the faux encaustic acrylic medium recipe (found on page 7). Experiment with changing viscosities.

2 Apply to Surface
Apply the recipe to a portion of the surface using a palette knife.

3 Add Water and Spread
Add water to the spreadable faux encaustic mixture to change its viscosity. Then apply it to the lower surface area.

4 Thicken the Recipe
Apply extra-heavy gel molding paste to the top portion of the painting. (Don't apply too thick.)

5 Spread the Recipe
Smooth the mediums across the panel and let it dry. Add layers according to your preference. This is a good way to see how the recipe looks thick or thin compared to the extra heavy gel molding paste.

Layering

It is always best to begin with a thin layer, let it dry and then add more layers to increase the opacity. If you start with a layer that is too thick, you can't go back!

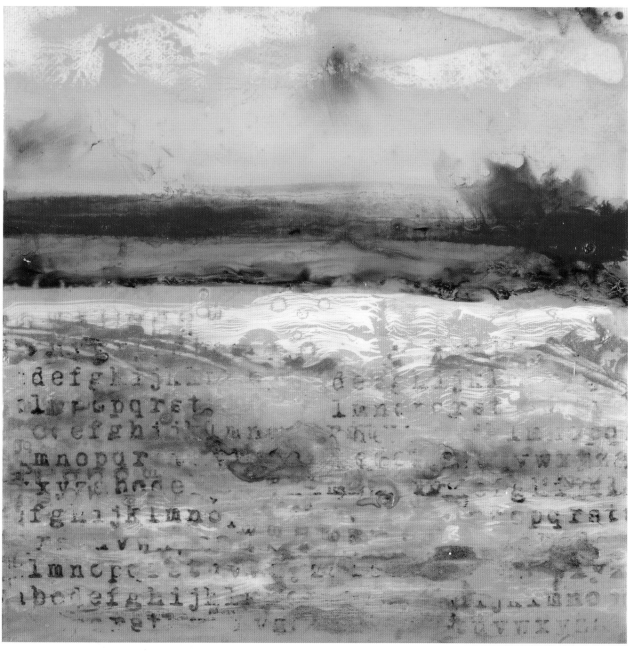

Materials list

MEDIUMS
fluid matte medium, polymer medium gloss, self-leveling gel, soft gel gloss

PAINTS
Apricot, Baltic Green, Lime Green, Metallic Blue, Red Iron Oxide, Sepia, white, yellow

MISC.
alcohol, Ampersand Claybord, Elmer's glue, letter stamp, palette knife, spray bottle, StazOn ink (brown), water

Pourable Formula Recipes

***Pourable Faux Encaustic 1:** (soft gel gloss, polymer medium gloss, fluid matte medium, water)
Begin by mixing equal parts of the mediums and gels. Then add water to get a brushable or pourable viscosity. You can always add more or less matte to alter the sheen. (Shake it up to add bubbles.)

***Pourable Faux Encaustic 2:** (fluid matte medium, self-leveling gel, water)
Begin with equal parts of gel and medium. Add water to create the viscosity desired. This formula tends to have the fewest number of brushstrokes due to the self-leveling gel. Apply a fine mist of alcohol on top of the poured medium to pop any bubbles. Don't shake this formula.

2. **Pourable** Formulas

It's all about the layers when you want to create a faux-encaustic painting. The eye can detect microns of depth, so if you add clear pourable layers and then add paint on top of that, you will create some wonderful depth. Keep layering and you'll get a painting you can jump right into.

Pourable and brushable formulas are much thinner than the spreadable mixtures, so these will be used on a smoother surface.

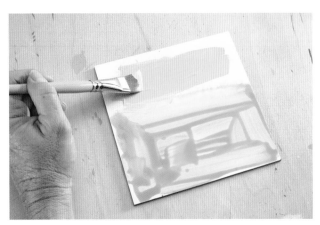

1 Apply Water and Paint
Apply water to the Claybord, then rub it into the surface. Add Apricot paint to the top and Lime Green to the bottom. Mist the paint with water, then spread it across the canvas. Let it dry.

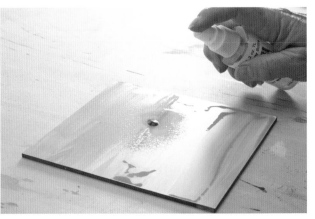

2 Apply Water and Add Another Layer
Mist the surface with water, then apply Red Iron Oxide to the center. Once blended, let it dry.

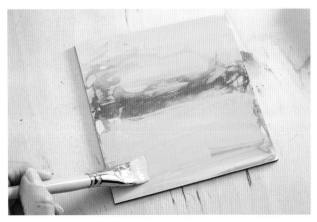

3 Add Paint to the Lower Half of the Canvas
Mix Baltic Green with white and dilute it with a small amount of water. Apply paint to the lower portion of the painting. Let it dry.

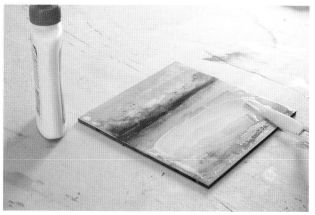

4 Apply Elmer's Glue

Apply Elmer's glue across the bottom portion of the painting using a palette knife.

5 Add Paint to the Glue

While the glue is still wet, use a brush to spread white paint over the glue. Lightly float the paint on top of the glue, being careful not to mix it with the glue.

6 Let It Dry

Let it dry until it begins to crackle. The cracks will occur in the direction of the brushstrokes.

7 Apply Alcohol Drops

While the surface is still wet, randomly apply alcohol drops along the crackled surface. Let it dry.

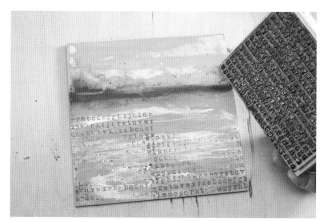

8 Apply a Stamp to the Panel

Stamp with a letter stamp inked with StazOn brown ink, then dry.

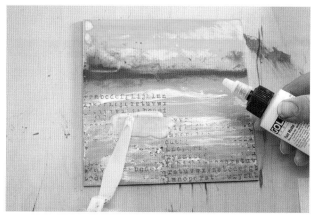

9 Create and Apply the New Mixture

Mix yellow and white paint into the Pourable Faux Encaustic 1 mixture. Then pour all of it over the lower area of the panel and spread with a palette knife.

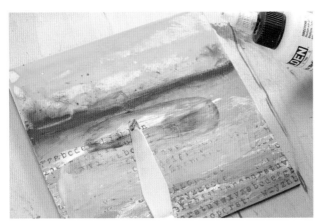 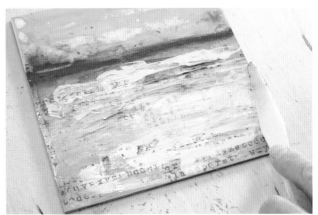

10 Create Another Mixture and Apply
Mix some Sepia or brown into the Pourable Faux Encaustic 2 medium, and pour it over the green area of the painting. Spread with the knife and let it dry.

11 Apply Metallic Blue Paint
Spread Metallic Blue randomly across the lower half of the painting, and let it dry.

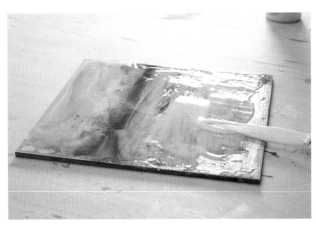

12 Apply Faux Encaustic Medium
Apply whichever pourable faux encaustic medium you choose over the entire painting.

Paint With Pour
When adding paint to the pouring formulas, put the tip of your knife into the paint and add a small amount at a time to the formula.

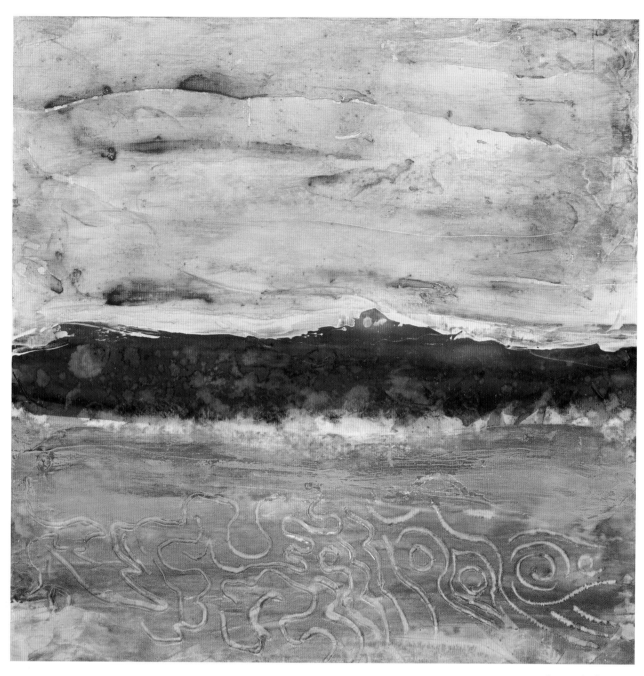

Sunset in Santa Fe
8" × 8" (20cm × 20cm)

Materials list

MEDIUMS
heavy gel matte, molding paste, soft gel gloss

PAINTS
Apricot, Cobalt Teal, Magenta, orange, Payne's Gray, purple, Quinacridone Gold, white

MISC.
alcohol, Ampersand Encausticbord, mixing cups, palette knife, paper towel, plastic wrap, silicone tool, spary bottle, water

Resist and Color

Use gloss as a resist. Use matte to hold color. Gloss mediums are smooth and will make the paint easier to remove, while the matte mediums will grab and hold paint.

3. **Resist** and Reveal

You can use the sheen as a resist tool by building layers and alternating sheens and opacity. The gloss gel layer will create texture and act as an isolation layer. It will make scribing back cleaner. The waxy paint will spread easily over the glossy and textured surface, and make it easier to scrape back to create depth. This is the closest we can get to the encaustic technique of scribing back into the wax. It's a bit trickier, but it can be done.

Mist Your Board

Lightly mist your board before you begin painting.

1 Apply Paint to the Surface
Apply Apricot paint over the entire Encausticbord surface and let it dry. Then apply orange paint over the top of the painting and Quinacridone Gold and Magenta across the bottom. The paint should be fairly fluid.

2 Place Plastic Wrap Onto the Surface
While the paint is still wet, place plastic wrap over the entire surface. Press down lightly, leaving air bubbles. If you want soft edges, remove the plastic wrap after a few minutes. If you want crisp edges, remove the plastic wrap after the paint is completely dry.

3 Paint and Apply Alcohol
Apply Magenta to the top portion and, while the paint is wet, add drops of alcohol across the surface. Let it dry.

4 Paint the Middle Section and Add Water
Add Payne's Gray to the middle area of the painting and, while the paint is still wet, apply water drops with a spray bottle across the surface.

5 Blot With a Paper Towel

When the paint is dry but the water drops are still wet, blot the surface with a paper towel. Let it dry.

6 Seal With an Isolation Resistance Layer

Using a palette knife, apply soft gel gloss over the entire piece to create texture and an isolation resistance layer. Let it dry.

Isolation Layers

The gloss layers make great isolation layers. Let's say you've built up a few layers and you wish to preserve them. Apply a layer of gloss gel or medium over them and let it dry—this is the isolation layer. Then you might try another color or resist on top, but you discover you don't like it. If you have a dried isolation layer below, you will be able to remove any paint you've applied over it. Even if the paint is dry, you can use alcohol on a towel and wipe it off. The isolation layer will preserve everything below it. I call it the *precious preservation layer*.

Handy Dandy Paper Towel

Keep a paper towel handy to frequently wipe off the paint your silicone tool picks up.

7 Scribe Into Wet Paint and Gel Mixture

Mix a small amount of Cobalt Teal paint into heavy gel matte and use the knife to spread the mixture over the bottom area. While the mixture is still wet, use a silicon tool or the handle end of the brush to scribe into the wet paint and gel mixture.

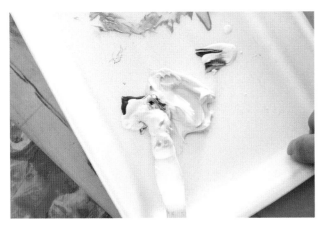

8 Apply Molding Paste

Apply some molding paste onto the upper portion of the painting and drop a few drops of white and purple on top of the paste and mix.

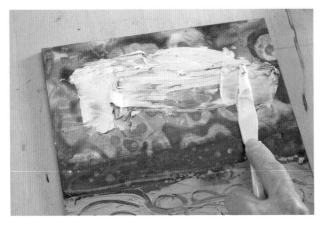

9 Spread the Paste and Paint

Use your palette knife to spread the paste and the paint across the top portion. (Be careful that you don't overmix. You want to be able to spread it thinly so you can still see some of the underlying layers.) Let it dry.

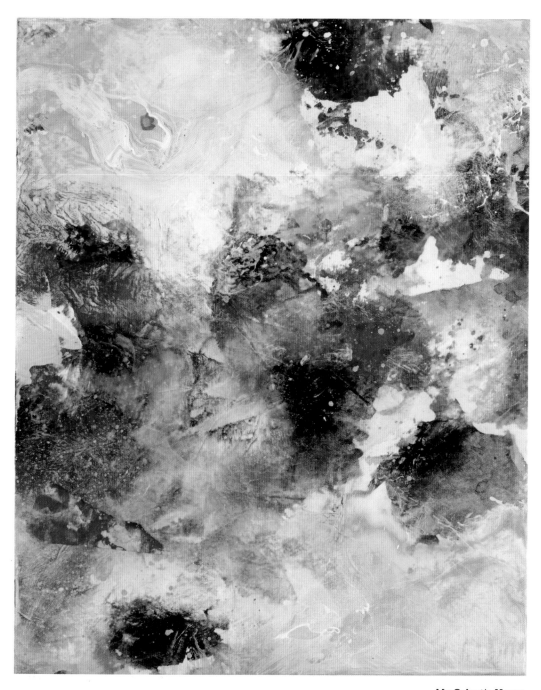

My Galactic Home
8" × 10" (20cm × 25cm)

Materials list

MEDIUMS
heavy gel matte, soft gel gloss

PAINTS
Payne's Gray, Quinacridone Burnt Orange, Quinac-
ridone Gold, white, yellow

MISC.
Ampersand Encausticbord panel, book or board,
brayer, deli sheets, plastic wrap, spray bottle with
water, stencils

4. **Deli** Paper

These thin but sturdy papers give you an automatic double-sided layer. For a quick wax look, paint on one or both sides and apply to an existing painting.

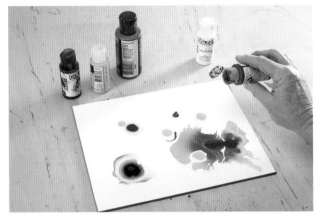

1 **Mist the Panel and Apply Color**
Mist the panel surface with water and apply a few drops of two to three colors, plus white. I used Payne's Gray, Quinacridone Burnt Orange, white and yellow.

2 **Spritz Water and Apply a Deli Sheet**
Spritz the panel with water before lightly placing a deli sheet onto the wet surface.

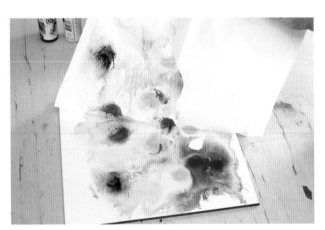

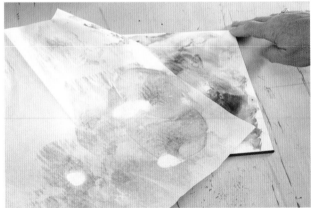

3 **Drag the Deli Sheet Across the Panel**
Drag the deli sheet over the panel.

4 **Draw the Deli Sheet in a Different Direction**
Pick up the deli sheet and twist it to apply the color to different areas. Keep some areas of the deli sheet free from the paint. Set it aside to dry. This can be used as a collage paper.

Extra Sheets

Use extra deli sheets to remove more paint if the paint is too thick. Don't overmix or you'll get mud.

Resists

If desired, you can use alcohol or water as a resist.

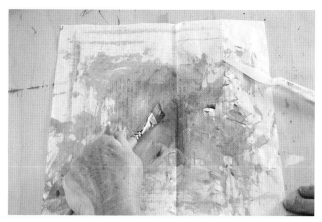

5 Apply a Layer of Paint on the Back

Apply a mixture of white and a brightly colored paint onto the back of a used deli sheet to accent the colors on the front.

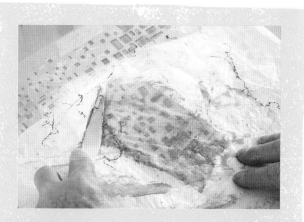

Deli Trick

Use up any leftover paint by mixing it into a soft gel gloss, then spread the mixture onto a deli sheet over a textured surface.

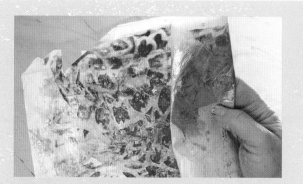

Stencils

Any type of gel may be mixed with paint to make stencil papers. Get creative by using different gels or pastes with stencils. Then add an accent color on the back of the deli sheet to emphasize the stencil pattern used.

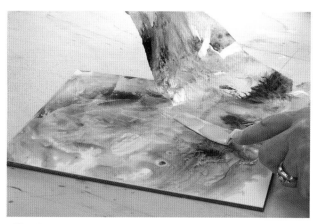

6 Alter the Composition

Alter your composition by applying soft gel gloss onto the surface and placing the deli sheet onto it. Add paint to the back of the deli sheet before adhering it.

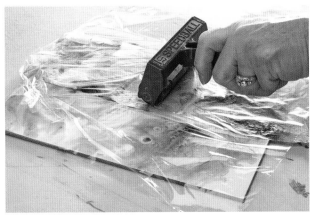

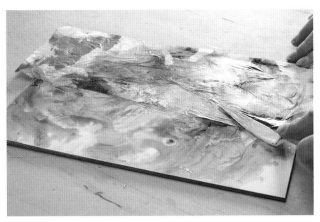

7 Use a Brayer
Apply a piece of plastic wrap over the panel, then use a brayer to roll out any bubbles. Place a book or board over the plastic wrap until the piece is dry. Then remove the book and the plastic wrap.

8 Layer Additional Deli Sheets
Continue to add deli sheets to your composition, as desired.

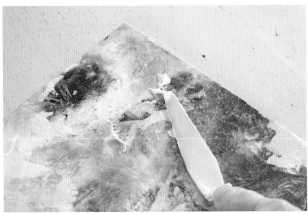

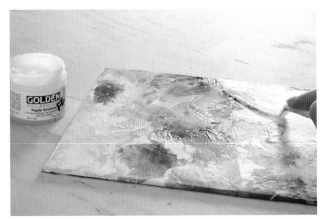

9 Add Collage Elements
Apply collage elements by cutting up a deli sheet and applying random cutout pieces onto the surface with your medium of choice. Add more paint on top to integrate the layers. Let it dry.

10 Seal the Final Layer
Apply a thick layer of spreadable faux encaustic across the panel to achieve a waxy look.

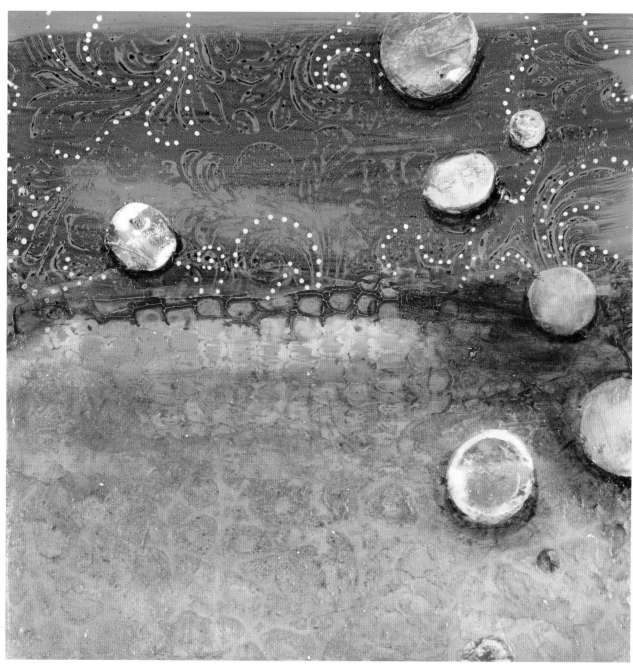

Time is an Illusion
8" × 8" (20cm × 20cm)

Materials list

MEDIUMS
light molding paste, molding paste, pourable faux encaustic, soft gel gloss, spreadable faux encaustic

PAINTS
Apricot, brown, Payne's Gray, green, Sepia, Teal Blue, white

MISC.
Ampersand Encausticbord panel, DecoArt white paint pen, deli sheets, scissors, soft-textured paper (or foam stamp or fabric)

5. Emboss

You can create textures using different gels and pastes or even paints. Both applied and implied textures are possible to create. The implied texture looks like a pattern or texture, but it's smooth to the touch, whereas the applied texture has physical depth. Due to these different textures, different faux encaustic finishes must be used.

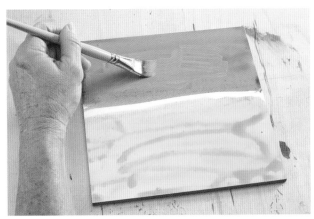

1 Paint the Background
Paint a background on Encausticbord using Teal Blue in the top portion and Apricot in the lower half. Let it dry.

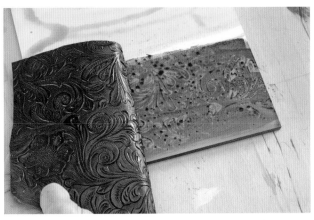

2 Create a Stamping Effect
Apply a thin layer of Payne's Gray on top of the Teal Blue and immediately stamp it with a soft-textured paper, foam stamp or fabric.

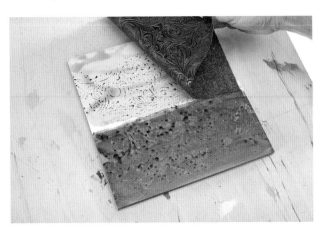

3 Stamp the Other Half of the Panel
Press and pull up the tool or material that you stamped into the Payne's Gray, and stamp it onto the Apricot side of the panel. This will create an imperfect image—which means you did it correctly!

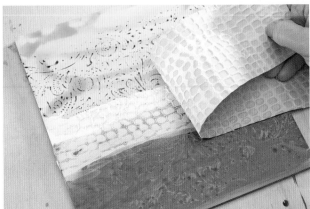

4 Apply Molding Paste and Textured Paper
Apply a thin layer of molding paste to the center section and press a textured paper into the wet paste. Pull off the textured paper and let the panel dry.

Redo

If the layer is too thick and you're not able to get a good impression, then wipe it off and apply a thinner layer and repeat.

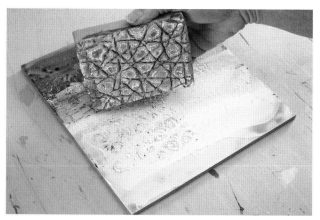

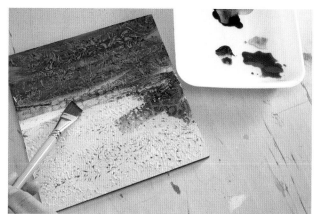

5 Apply Molding Paste and Stamp
Apply light molding paste to the Apricot side, and press a foam stamp into the wet paste. Let it dry and wash the paste from the stamp immediately.

6 Apply Layer(s) of Paint
After the paste is dry, apply a thin layer of watered down Sepia to the light molding paste section. Blot and build up as desired. Leave some areas unpainted so you can see the various background layers.

Don't Waste

Discharge any leftover paste onto a deli sheet, an extra panel or a piece of paper for future use.

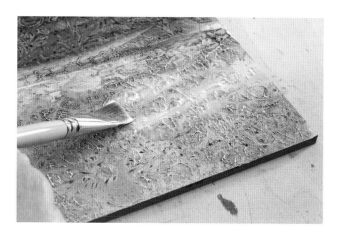

7 Add Paint Layers and Faux Encaustic Layer
Apply a mixture of fluid green and white paint on a dry brush and drag it over the surface of the light molding paste. The paint will sit on the high spots. Let the paint dry, then repeat using a brown paint. Once finished, apply a pourable faux encaustic mix, and let it dry.

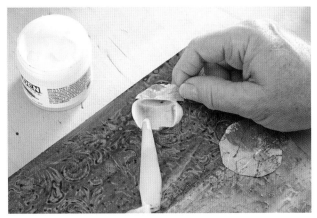

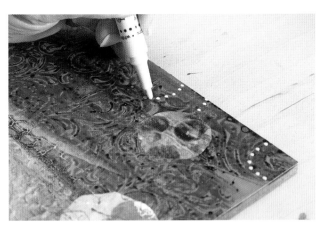

8 Adhere Collage Elements
Cut out collage shapes from deli papers and use a soft gel gloss to glue them down. Let them dry.

Create Your Own!

Visit CreateMixedMedia.com/encaustic-effects to learn how to make your own wax element.

9 Add Dots, Layers and Seal
Use a DecoArt white pen to make dots along the blue portion of the panel. Apply a spreadable faux encaustic mix to the light molding paste texture section and let it dry. Apply more layers of dots and glazes if desired. When all layers are dry, seal with a pourable faux encaustic mixture of your choice.

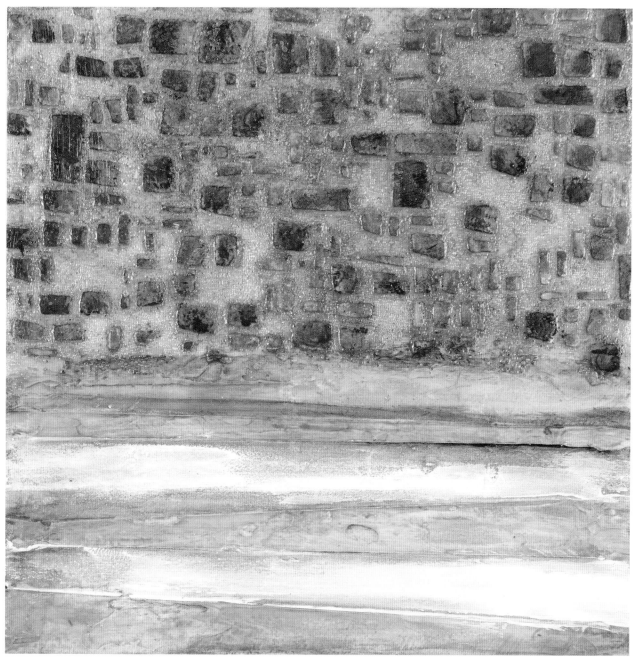

City Life
8" × 8" (20cm × 20cm)

Materials list

MEDIUMS

glass bead gel, light molding paste, soft gel gloss

PAINTS

green, Iridescent Bronze, Quinacridone Burnt Orange, Quinacridone Gold, Sepia, white

MISC.

Ampersand panel, masking tape, silicone shaper tool, palette knife, paper towel, spray bottle, stencils: rectangles and bars

6. Way of the Stencil

A stencil is a great tool for building up a surface and filling in the recesses with gels and pastes. It adds great depth and fun ways to build layers using different sheens and mediums.

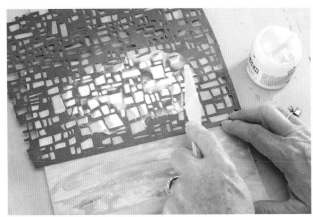

1 Paint the Background and Apply Stencil
Paint the background with Quinacridone Gold mixed with white and let it dry. Place the stencil onto the surface and, using a palette knife, apply light molding paste through the stencil.

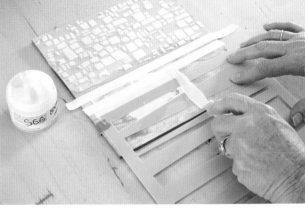

2 Apply Soft Gel Gloss
Use a palette knife to apply soft gel gloss over a stencil and strips of masking tape. Remove the tape and stencil, then clean the stencil. Let the soft gel gloss dry.

Unusual Places

Find stencils in unusual places. In this demonstration the rectangle stencil is fabric and the blue stencil is from the cake decorating department.

Unique Texture

Specialty gels, like glass bead gel, can provide a unique texture.

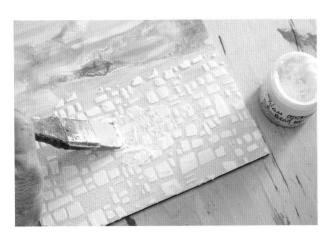

3 Apply Glass Bead Gel
Use a silicone tool or knife to spread glass bead gel over the top half of the panel where the rectangles and square shapes are. Let the beads go into the recesses, and let the layer dry.

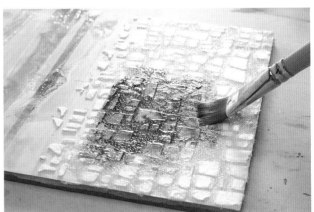

4 Apply Diluted Paint
Using a brush, apply diluted Quinacridone Gold mixed with white paint over the glass bead gel. Mist lightly with water and let the paint run over the glass bead gel. Build up the paint color in layers on top of the beads.

5 Remove the Excess From the Panel

Use a paper towel to remove excess and let it dry.

Multitasking

Gels and pastes, when applied thickly, can take a while to dry. Don't rush it or force them to dry quickly. Work on another piece while you wait for this one to dry.

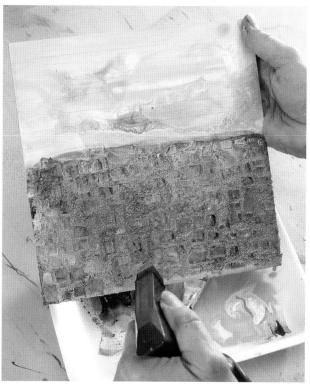

6 Apply a Diluted Layer of Paint

Finish painting with a layer of green, Quinacridone Burnt Orange and white. Spray the panel with water to dilute the paint.

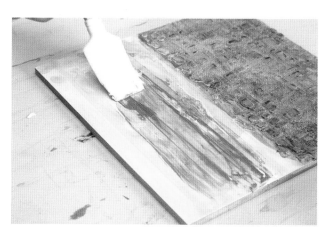

7 Add Paint and Light Molding Paste

Mix in a tiny bit of Iridescent Bronze paint into light molding paste and apply the mixture between the strips of gloss gel.

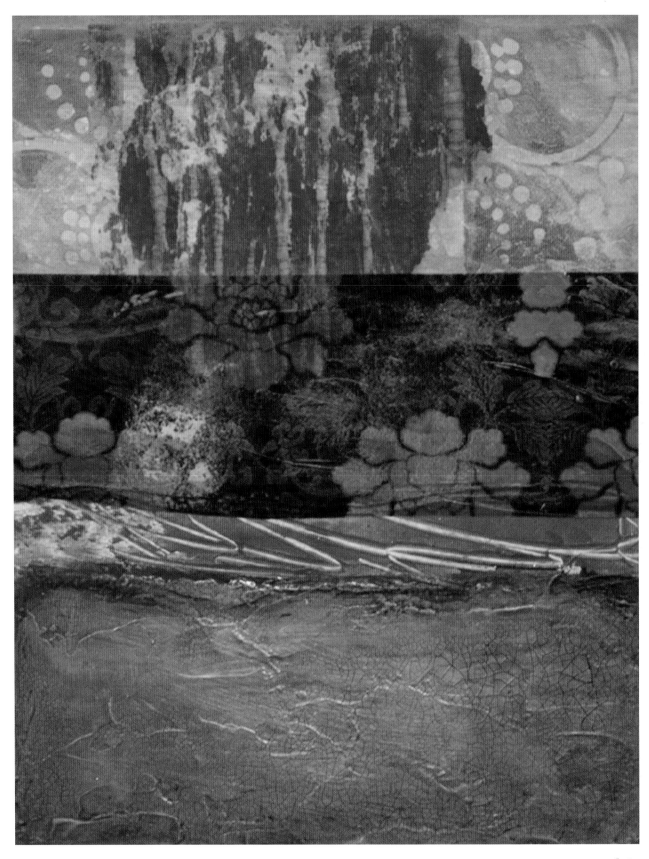

Lotus
10" × 8" (25cm × 20cm)

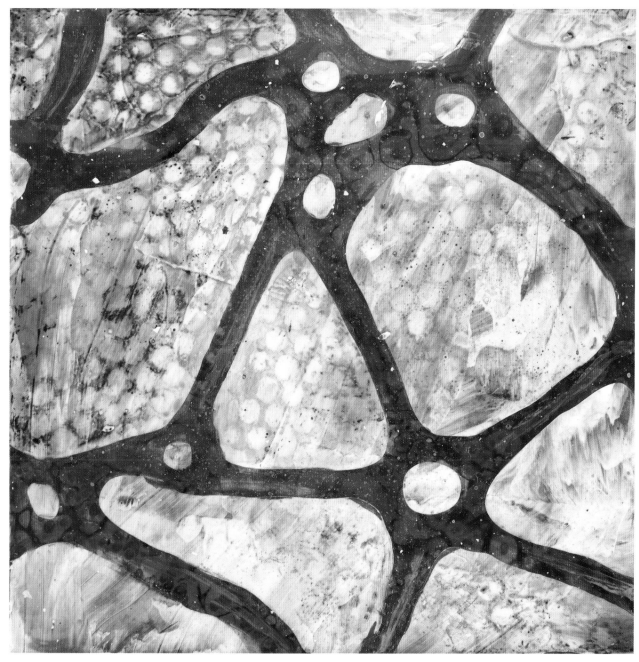

Quantum View
6" × 6" (15cm × 15cm)

Materials list

MEDIUMS
pourable faux encaustic, heavy gel semigloss

PAINTS
Cobalt Teal, Diarylide Yellow, Magenta, Payne's Gray, Pyrrole Orange, Pyrrole Red, Raw or Burnt Umber, white

MISC.
alcohol, Ampersand Encausticbord panel, cotton swab, deli sheets, paper towel, squeeze bottle, stencils

Carving Effect
Build up a thick layer to look like a carving by using a stencil with a lot of open area (large openings). You can also make your own stencils to get this look.

7. Reverse Stencil

This technique is the closest way to get that "carved into" look that is often found in wax. You want to use a stencil that has large openings that create the look of lines. This is similar to the previous technique except that the large areas will cover up the background.

Rough Patch

If you are using a stencil over a surface that isn't totally smooth, first apply gloss gel through the stencil and then immediately add any gel or paste with paint mixed in. Remove your stencil and clean it. The gloss gel will dry clear and keep the paint from flowing underneath the stencil, thereby creating a nice, crisp edge.

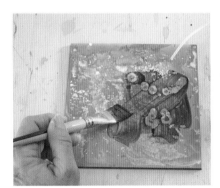

1 Apply Paint and Alcohol
Apply drops of Pyrrole Red, Pyrrole Orange and Diarylide Yellow onto the surface. Spray water and use a brush to lightly blend the colors. Blot the surface with deli paper in some areas to remove extra paint and let it dry. Brush a thin layer of fluid Umber over the red-orange layer and, while the paint is wet, drop alcohol onto the surface to create a resist pattern. Let it dry.

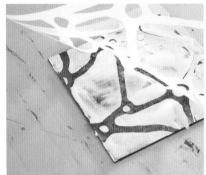

2 Apply Medium and Paint Through a Stencil
Apply heavy gel semigloss mixed with a few drops of white through the stencil. Let it dry.

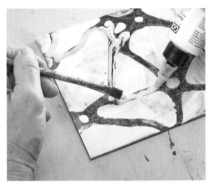

3 Add Faux Encaustic
Apply a faux encaustic pouring medium from a squeeze bottle into the recessed areas of the stencil pattern. Apply diluted Magenta lightly with a brush into the wet faux encaustic medium.

Stencil Upkeep

Remove the stencil and blot off the paste onto a paper and then wash the stencil. Don't let the gels or pastes dry on your stencils.

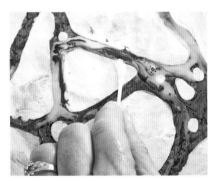

4 Clean the Edges
Move the medium around and use a cotton swab to clean up the edges. Let it dry.

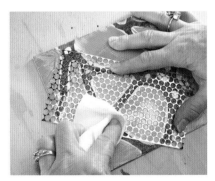

5 Apply Paint and Stencils
Apply a very thin layer of diluted Cobalt Teal on top of the white areas. Let it dry, then place a stencil on top and use a paper towel with alcohol to rub off the paint. Continue to add layers of stencilled effects.

6 Seal Final Layer
Seal with a layer of pourable faux encaustic, then let it dry. Apply diluted Payne's Gray and repeat the alcohol erase before finishing with a faux encaustic mixture of your choice.

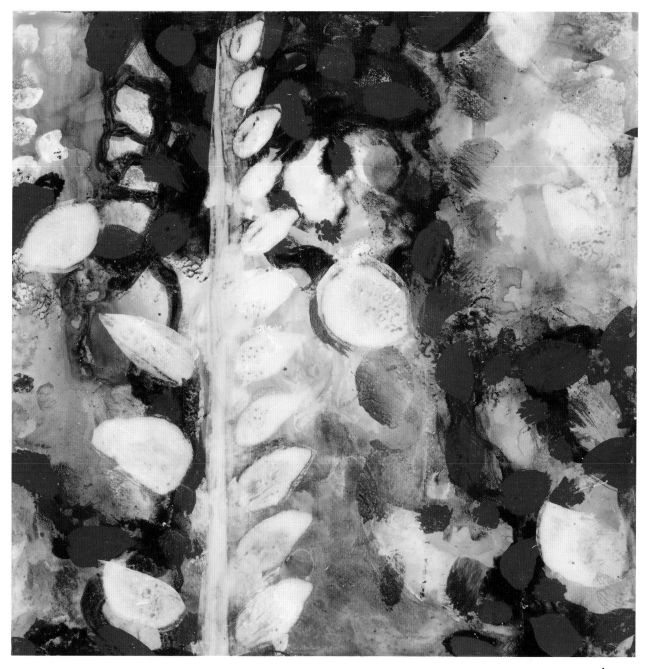

Aspens
8" × 8" (20cm × 20cm)

Materials list

MEDIUMS
gel matte (or satin), heavy gel semigloss

PAINTS
Lime Green, Phthalo Turquoise, Red Iron Oxide,
Sap Green, white, yellow

MISC.
Ampersand Encausticbord panel, palette knife,
plastic (from a painter's drop cloth), satin varnish,
scissors, sponges, spray bottle, stencils

8. Wax Elements

This is so much fun to do and you can save your elements for future use, too. It's another unique way to use stencils, and the best part is that you don't have to clean your stencil! You may also use different pastes with or without paint.

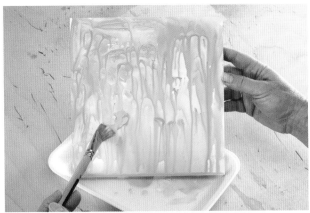

1 Apply Paint to the Panel
Mist Encausticbord with water and apply drops of white, Lime Green and yellow paint. Mist with more water, then tilt and move the panel around to get the paint to move. Let it dry. Mix Phthalo Turquoise with white and Sap Green paint, then apply it to the panel with a brush. Mist the layer of paint and get it to move around.

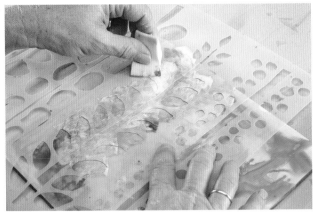

2 Apply Paint Through a Stencil
When the paint is dry, mix Phthalo Turquoise with white, and use a sponge to apply paint through a stencil. Let it dry.

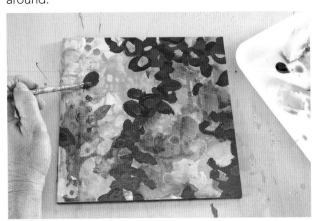

3 Paint Another Layer
Paint Red Iron Oxide onto the surface. Let it dry.

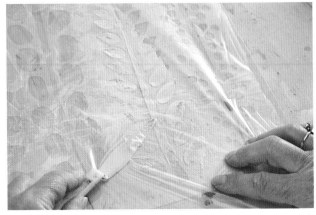

4 Create Wax Elements
Make wax elements by mixing yellow and white, and combining it with heavy gel semigloss. Place a piece of plastic over the stencil and use a palette knife to spread the mixture on top of the plastic. Let the paint dry thoroughly.

Moving Stencils
If your stencil moves while applying the gel, simply spread it again.

Painted Side
Place a small piece of masking tape onto the plastic that has the paint on it to identify which side was used.

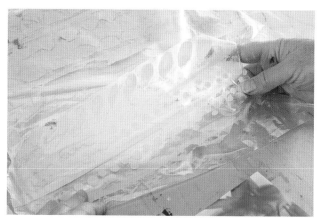
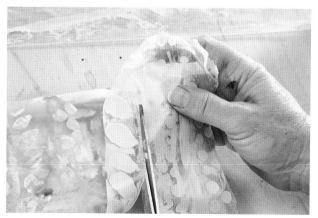

5 Peel off the Wax Element

When the wax element is dry, peel it off the plastic and cut it into a desired shape.

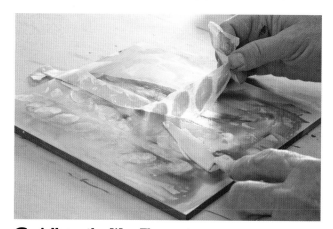
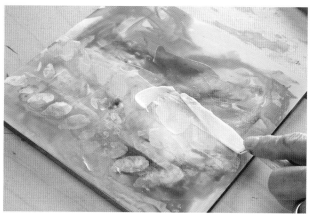

6 Adhere the Wax Element

Use a gel, satin or matte to adhere the cut wax element to the painting. Work with your composition, adding as many elements and as much paint as desired. (In this sample I had not painted with Red Iron Oxide yet.)

Sticky Situations

Use wax paper in between acrylic on plastic to prevent it from sticking together.

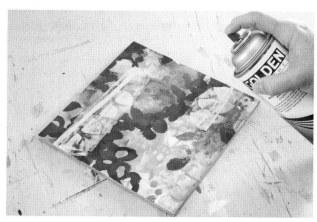

Repetition

You can use repetition as a design element. Simply use the same stencil with the paint and then again for the wax element shapes. Doing so will create depth. You can also create different size elements of the same shape (or cut your wax shapes into similar arrangements) to get a unique look.

7 Seal Final Layer

Since the painting already has wax elements, spray with a satin varnish to unify the sheen.

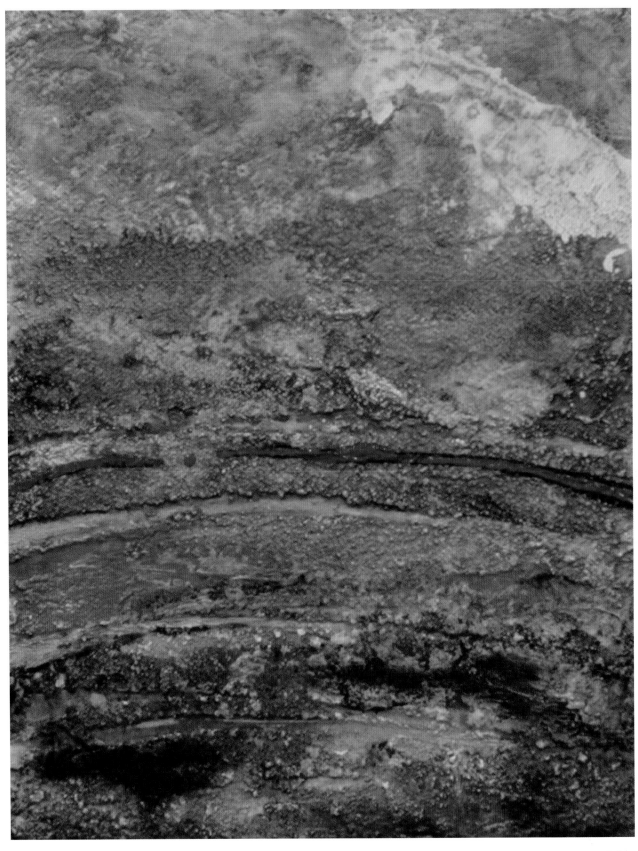

Saturn
10" × 8" (25cm × 20cm)

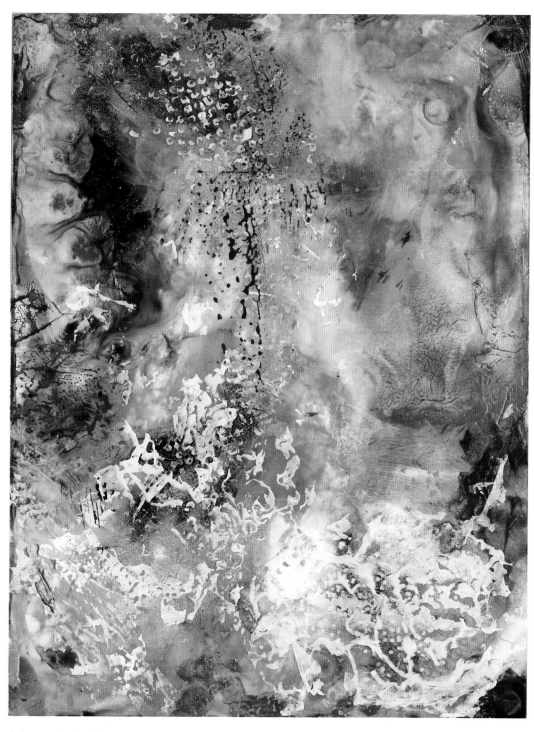

Space Travel Dreams
12" × 9" (30cm × 23cm)

Materials list

MEDIUMS
soft gel gloss

PAINTS
white, yellow

MISC.
Ampersand Encausticbord panel, cooking parchment paper, iron, painter's tape, palette knife, papers, plastic, scissors, texture plates

Plastic Tips

Any high-density polyethylene plastic will work (plastic bags, drop cloths, trash bags, etc.). I prefer to use clear plastic so that I can see the background beneath the plastic.

9. Thin Skins

Thin skins are similar to wax elements, but they are very thin. I like to keep my workspace covered in plastic and then I blot stamps, clean off stencils and use up leftover paint. When this is all dry, it is a thin skin.

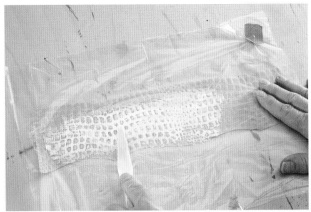

1 Paint Over a Textured Surface
Mix soft gel gloss into a mixture of white and yellow paint. Place plastic over a texture plate or paper, and hold it in place. Use a palette knife to scrape the mixture on top of the plastic. Let it dry.

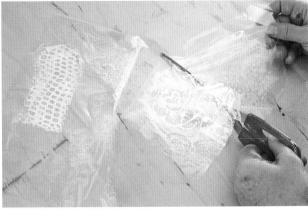

2 Cut up Plastic
Cut up an area of your painted plastic sheet. Place a small piece of tape onto the side with the paint. Sometimes it is difficult to tell which side has the paint on it.

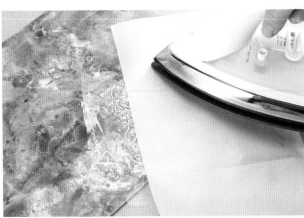

3 Adhere the Thin Skin
Heat iron to a synthetic setting. Place plastic with paint side down where you want to transfer your thin skin. Put a piece of cooking parchment paper over the plastic and painting. Be sure your iron is set for no steam and a medium setting. Press down with the iron. Do not directly touch the plastic or it will melt. Let the plastic cool and pull it off by stretching it in your direction. The thin skin should stay. To ensure good adhesion, once the plastic has been removed, put the parchment on top of the thin skin and iron longer, pushing down onto the surface.

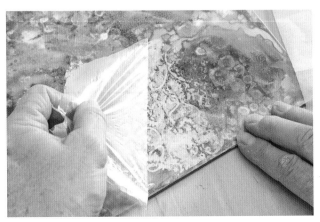

4 Add More Layers to the Panel
Add more layers by stamping or integrating more sheets.

Ironing

To iron your skin onto a painting, the painting must have some acrylic paint or gel adhered to it. The skin and the acrylic need to be able to "melt" together.

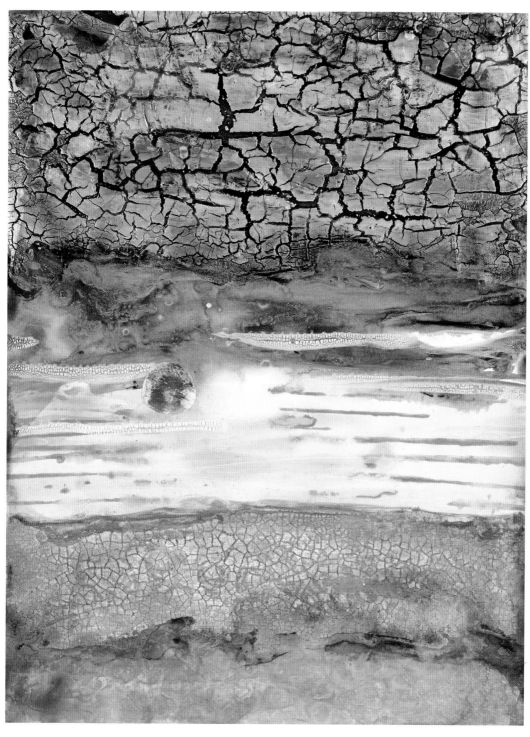

Moonlit Night
12" × 9" (30cm × 23cm)

Materials list

MEDIUMS
DecoArt Media Crackle Paste, decoupage satin (or gel or glue), Elmer's Glue-All, Kroma Crackle

PAINTS
Payne's Gray, Sepia, silver, white, Yellow Ochre

MISC.
alcohol, Ampersand Encausticbord panel, collage embellishments, foam stamp, heat gun, palette knife, paper towel, sandpaper

10. All Cracked Up

You can't really use crackles with wax, but they are one of my favorite products for creating faux encaustic effects. I love all the different varieties of crackle finishes you can get: Large and small, clear and colorful. The cracks open up and reveal the underlying layers. It's all about those layers.

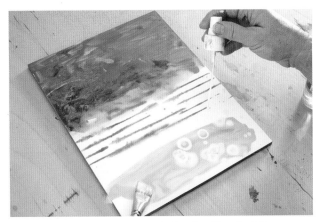

1 Paint the Surface and Apply Alcohol Drops
Using a brush, apply a mixture of Payne's Gray and white paint to the surface. While the paint is wet, drop some alcohol onto the surface to create a resist. Let it dry.

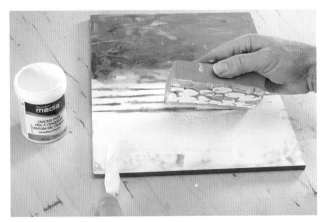

2 Apply Paste and Stamp Into the Panel
Apply DecoArt Media Crackle Paste over the lower portion of the panel. Use your palette knife to spread the paste and apply it thinly in one area. Press a foam stamp into the wet paste, then remove the stamp and let the panel dry.

Get a Reaction

If you don't get a reaction, either your paint was too thick or too dry. Wipe it off and try again.

Crack'a Lackin'

If you don't have crackle in the tube, use your palette knife to apply a line.

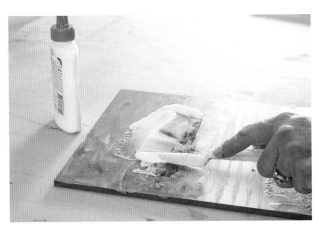

3 Spread Glue Onto the Surface
On the upper portion, spread a layer of Elmer's Glue-All onto the surface with your palette knife. Let it dry.

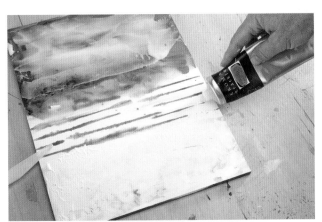

4 Apply Kroma Crackle to the Panel
Squeeze Kroma Crackle directly onto the section in strips.

Visit CreateMixedMedia.com/encaustic-effects for bonus materials!

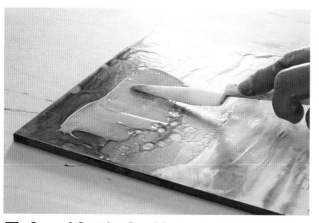

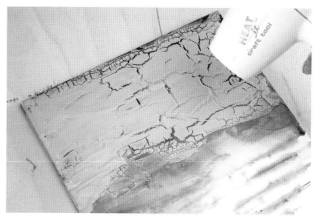

5 Spread Out the Crackle

Use a knife to apply Kroma Crackle medium mixed with a small amount of silver paint. Dry with a heat gun or let the panel dry naturally.

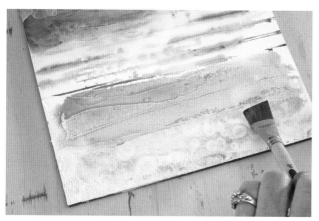

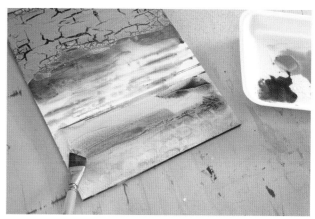

6 Apply Paint to the Panel and Blot

Mist the dry crackle medium with water and apply diluted Yellow Ochre. Let the diluted paint sit a few minutes before blotting it with a towel. Do the same with Sepia.

7 Build up Your Painting

Continue to build up your color until you are satisfied. Then let it dry. If desired, apply collage using decoupage satin. You may also use a gel or any other glue. I used cut shapes from some deli sheets that were leftover from prior uses.

Misting Magic

Always mist crackle before applying paint.

Too Much Color?

Let everything dry then sand the crackle.

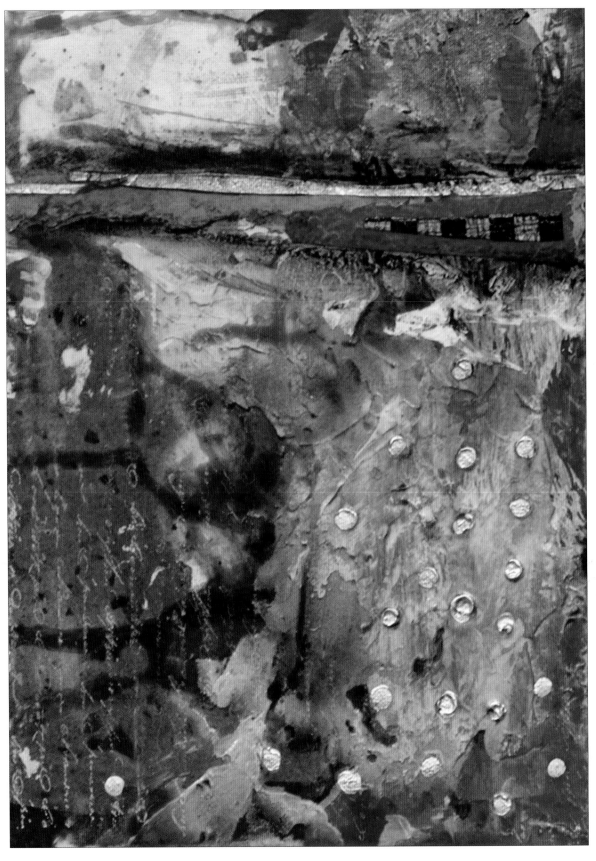

Visions
7" × 5" (18cm × 13cm)

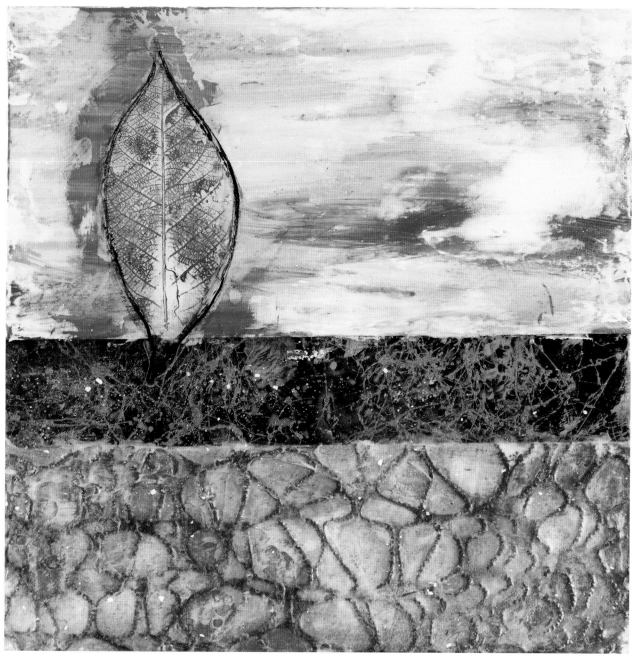

Materials list

MEDIUMS
polymer medium (or acrylic glazing liquid), soft gel gloss, spreadable faux encaustic, Venetian plaster

PAINTS
Burnt Crimson, Cobalt Teal, purple, Transparent Brown, yellow, Zinc White

MISC.
Ampersand Claybord panel, brayer, Dura-Lar, green scrub sponge, palette knife, paper towel, leaf skeleton, plastic wrap, ribbon, spray bottle

11. Embedding

The embedding technique is done frequently with wax, but this project shows you how to get the same effect using acrylic. Here you'll embed objects, both thick and thin, using different mediums—including Venetian plaster.

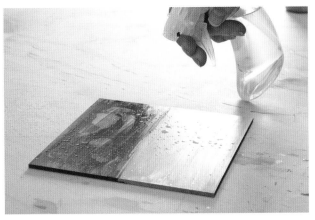

1 Apply Paint
Apply yellow, Burnt Crimson and Transparent Brown paint to the surface. Spray water drops onto the surface.

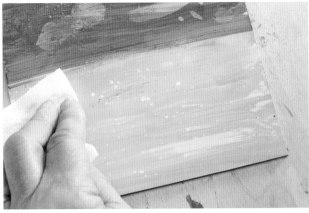

2 Wipe off Water Droplets
When the paint is dry but the water drops are still present, wipe off the water drops with a paper towel.

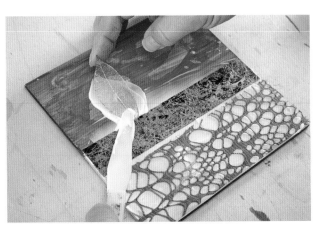

3 Apply Soft Gel Gloss and Embellishments
Apply soft gel gloss to the surface. Arrange the leaf, a blue ribbon and Dura-Lar onto the wet gel surface.

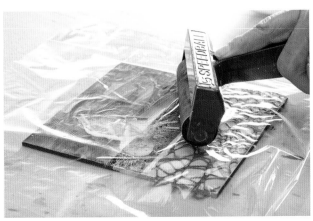

4 Adhere Elements and Let the Panel Dry
Place plastic wrap over the elements and, using a brayer, roll and press to adhere the elements. Carefully remove the plastic and let the panel dry completely.

Adding Depth

A transparent collage element adds depth with paint applied on both sides. Try different collage elements and different pastes. Dura-Lar is an archival transparent sheet that can be painted on both sides and used as a collage element.

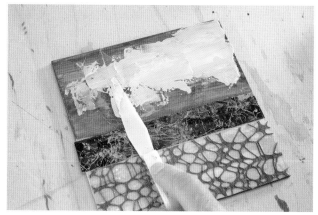

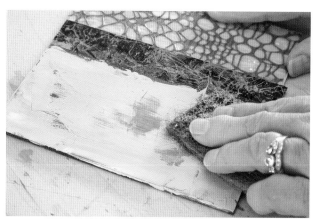

5 Apply Venetian Plaster Mixture
Mix a small amount of Cobalt Teal into the Venetian plaster and cover the top portion of the painting. Let it dry.

6 Remove Some of the Plaster
Once the plaster is dry, use a scrub sponge to remove some of the plaster. Repeat the previous step, mixing in purple with the plaster. Let it dry, then remove some of the plaster with a damp green scrub sponge.

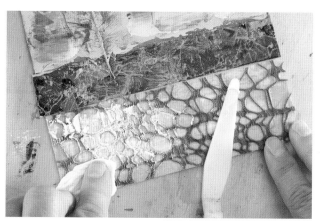

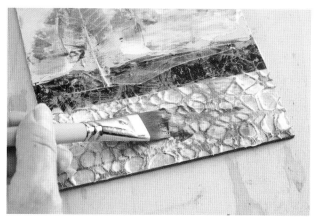

7 Add a Layer of Paint
Mix some Zinc White into soft gel gloss and use your palette knife to apply the paint over the section of the blue ribbon. Let it dry.

8 Apply Final Touches
Make glazes using either polymer medium or acrylic glazing liquid. Mix a small amount of paint into the medium and use a brush to apply it over the lower portion of the painting. Let it dry, and repeat using another colored glaze. Continue to build up the layers of color. When satisfied, cover with spreadable faux encaustic.

Muddy Mayhap
To avoid making mud when applying glazes, let each layer dry before putting on the next color. The same is true for plaster.

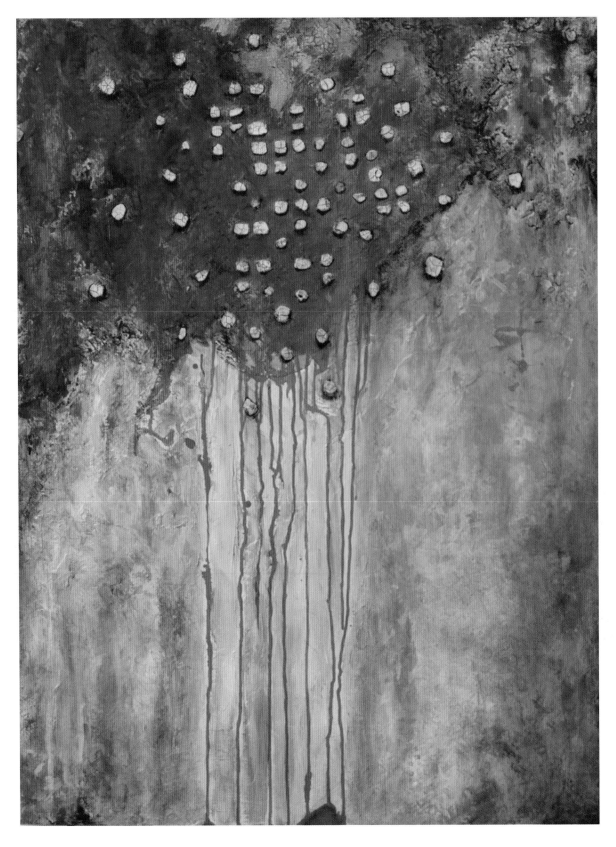

Invisible Matter
40" × 30" (102cm × 76cm)

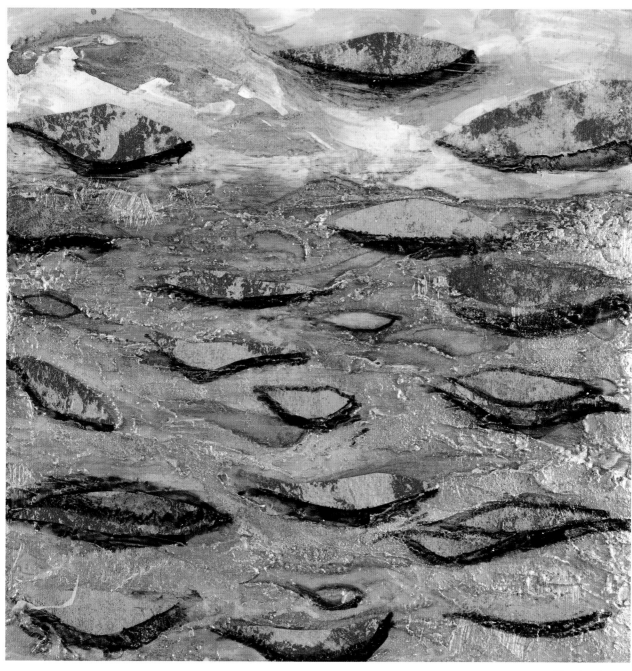

Floating Leaves
8" × 8" (20cm × 20cm)

Materials list

MEDIUMS
light molding paste, spreadable faux encaustic

PAINTS
blue, gold, green, Iridescent Bronze,
Metallic Blue, Red Copper, silver

MISC.
Ampersand Encausticbord (previously painted), dryer sheets,
palette knife, plastic, stencil

Dryer Sheets

I like to reuse dryer sheets. I use them several times in the dryer to remove all the product from them, then I wash and dry them before using them for my art. Keep these sheets around, just like the deli sheets, to use up extra paints and mediums, to clean stamps, etc. You'll end up with some wonderful collage elements!

12. Emphasizing Texture

Drybrushing over textures can create a similar look as the encaustic accretion technique. *Encaustic accretion* is the building up of layers of wax using a cold or dry-brush technique to create raised areas. It is achieved in a similar fashion by drybrushing paint or medium over textures. Here we will use viscosities and mediums to build layers.

1 Apply Paint to the Panel and Paste Through a Stencil
Using your brush, apply Metallic Blue paint to the bottom area and green and Iridescent Bronze to the top of a previously painted panel. Brush a line of Red Copper paint across the middle. Let it dry. Then, using your knife, apply light molding paste through a stencil.

2 Paint Dryer Sheets
Place a used and washed dryer sheet onto a piece of plastic, and paint it with gold and Red Copper. Paint another dryer sheet with Iridescent Bronze and gold. Let them dry.

Fabulous Fabrics
You can also try using different fabrics instead of dryer sheets.

3 Apply a Wash
Apply a blue wash onto the dried light molding paste. Then drybrush with thick silver paint. Blot the thin paints and use a dry brush with the thicker paint and float it over the surface so it sits on the high points.

4 Final Finishes
Cut up dryer sheets into desired shapes and apply them to the surface using spreadable faux encaustic medium. Let the entire piece dry, then cover it with spreadable faux encaustic medium.

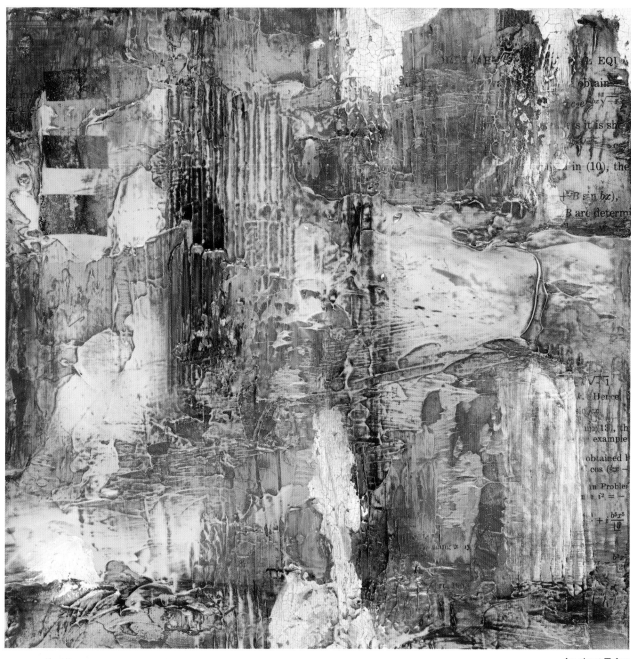

Ancient Tales
8" × 8" (20cm × 20cm)

Materials list

MEDIUMS
extra-heavy gel molding paste, molding paste, soft gel gloss, spreadable faux encaustic

PAINTS
DecoArt Crackle Paint, Iridescent Bronze, Metallic Blue, red, Sepia, Transparent Yellow, white, yellow

MISC.
alcohol, Ampersand Gessobord, collage elements, collage papers, palette knife, paper towel, plastic wrap, textured shelf liner plastic

This and That

I often use texture tools found around the house. In this project the textured shelf liner plastic can be cut into different sizes and directions. A corrugated cup holder works well, too.

13. Veiling

This is a simple painting technique that uses translucent gels and pastes to mimic the look of wax. The final sheen adds to the look of wax, too.

1 Build up the Background Layers
Paint the background red, let it dry and then brush a fluid Transparent Yellow onto the surface. While the paint is wet, lay a piece of plastic wrap on the surface. Let the plastic wrinkle and trap some air pockets. When you like the texture effect it creates, remove the plastic and let the panel dry. Adhere collage papers with soft gel gloss and let it dry. Add extra-heavy gel molding paste, pressing with a textured shelf liner plastic to create texture. Let it dry.

2 Apply Crackle Paint and Medium
Apply DecoArt Media Crackle Paint to a few small areas on the surface and let it dry. Using your palette knife, add a mixture of soft gel gloss mixed with white to the panel and let it dry.

3 Apply a Layer of Paint
Apply diluted Sepia over the dried pastes and gel.

4 Create and Apply Mixtures to the Panel
Make two different mixtures: One with Metallic Blue paint into molding paste and the other using yellow paint and extra-heavy gel molding paste. Apply mixtures in different areas using a palette knife, and let the panel dry completely.

5 Apply Final Touches
Add a diluted Iridescent Bronze paint over the dry pastes, and let it dry. Remove some of the paint using a paper towel with alcohol to bring back some highlights. Repeat this process using Sepia. Add collage elements, and finish with a layer of spreadable faux encaustic.

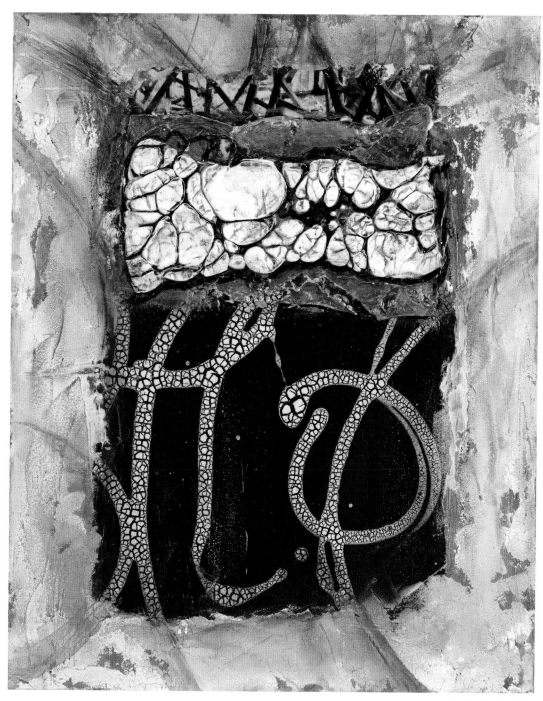

In the Beginning
10" × 8" (25cm × 20cm)

Materials list

MEDIUMS
light molding paste, polymer medium gloss, spreadable faux encaustic

PAINTS
light blue

MISC.
black paper, bleach pen, cooking parchment paper, iron, paper towels, scissors, sandpaper, Tyvek, water container, water-slide decal paper

Integrating Layers

Lightly sanding the transfers will help integrate them with the underlying layers. Be sure they are dry and cured before sanding.

14. Transfers

Want to create a wicked, weird texture, but you're worried that it may not last? Let's make it a transfer. I've written a few books on this topic, so I'll show you the fast way to make a transfer, but if you're interested you can research the many other ways to make a transfer.

1 Create Lines, Designs or Writing

Apply lines or writing onto black paper using a bleach pen. Let it dry and develop crackles, then print the image onto special water-slide decal paper. (For information on how to do this, visit CreateMixedMedia.com/encaustic-effects)

2 Iron the Tyvek

Cut your Tyvek about twice the size you want the finished piece to be. Place it between cooking parchment paper, and put it onto a heat-resistant surface. Iron with a medium iron and no steam. It will shrink quickly, so apply pressure to keep it from curling up.

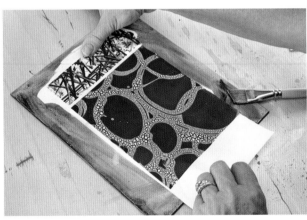

3 Place the Decal on the Panel

Paint the surface of your panel a light blue color and let it dry. Trim off the white edges from the water-slide decal transfer. Place the trimmed transfer face down in a tray of water. (Make sure it doesn't curl up, but if it does, press it down gently.) Apply a small amount of polymer medium gloss to the area of the panel where the decal will go. When the decal slides on the backing paper, it is ready to go. Gently blot the decal between paper towels before sliding it from the backing paper and onto the desired area. Smooth out any air bubbles and let it dry.

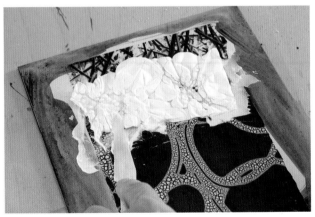

4 Apply Final Touches

Put some light molding paste onto the area where the Tyvek will go, and press it into place. Let it dry. Apply another water-slide decal, if desired. When completely dry, lightly sand the decals to integrate them into the background. Paint the dry light molding paste with watered-down paint, then let it dry and finish with a spreadable faux encaustic medium.

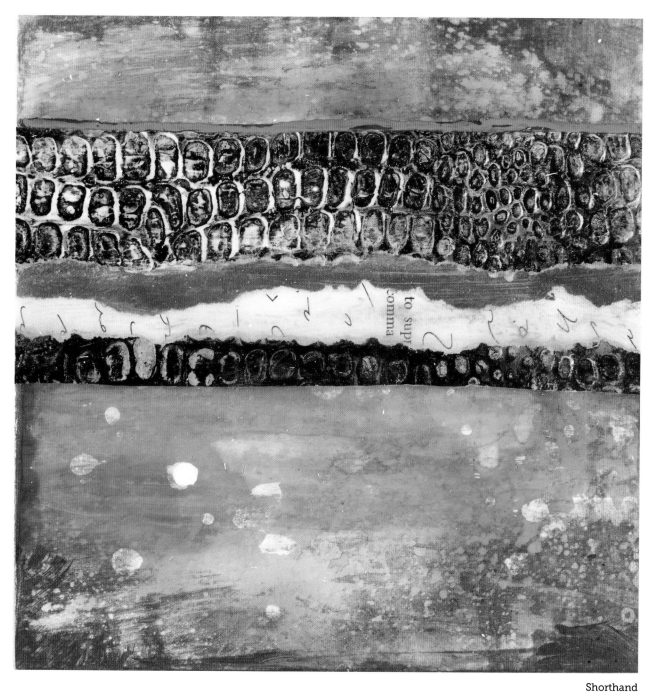

Shorthand
6" × 6" (15cm × 15cm)

Materials list

MEDIUMS
pourable faux encaustic, spreadable
faux encaustic

PAINTS
blue, Copper, Phthalo Green, Phthalo
Turquoise, red, white

MISC.
Ampersand Claybord, paper towel,
spray bottle

15. Collage

I keep all kinds of materials because, over time, they can develop wonderful textures or patinas on them. I have a specific set of papers that I've used to emboss into pastes and paints. When I collage these papers onto my surface and cover them with gels or faux encaustic mediums, I get an instant wax effect with a lot of depth. Here you'll embed textures into your painting using papers that have been used for embossing.

1 Build up the Background Layers
Mist some water onto the Claybord and rub it into the surface. Apply Copper paint onto the damp Claybord. While the paint is still wet, spinkle water drops onto the surface. Let the paint dry and blot the water drops off. Apply Phthalo Green to the top and bottom sections and Phthalo Turquoise in the middle. Let them dry. Adhere the texture papers and book pages with a spreadable faux encaustic medium.

2 Apply Layers of Paint
Apply a layer of spreadable faux encaustic and then add some Copper and blue paint. Drag some white paint mixed with spreadable faux encaustic over the texture paper.

3 Apply Final Touches
Add a red line for some zing and finish with a pourable faux encaustic.

Perfecting Collage Papers
- Experiment with different papers.
- To ensure that your papers will not fade, first treat them with a UV spray.
- For colored papers, paint the papers with a similar color prior to using them.
- Find an old phone book and place your collage papers on top of a page. Spread the medium onto the paper with a palette knife. Pick up a collage element and place it onto your painting. Cover it with plastic wrap and smooth it down. Remove the plastic and let it dry. Turn the page in your phone book—no mess.

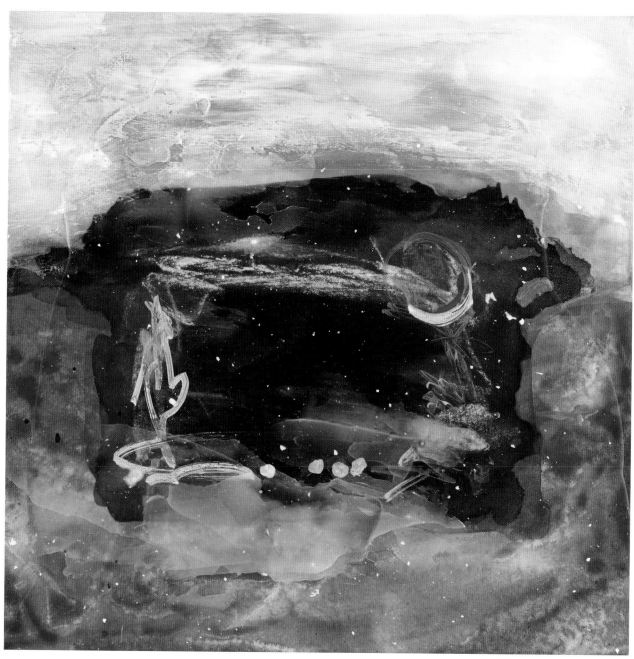

La Cueva 2
8" × 8" (20cm × 20cm)

Materials list

MEDIUMS
acrylic ground for pastels, extra-heavy gel molding paste

PAINTS
black, Iridescent Gold, Phthalo Green, Red Iron Oxide, Sap Green, Yellow Ochre

MISC.
Ampersand Encausticbord panel, pastels, deli sheet or paper towels, paint pens, palette knife, spray bottle, workable fixative

True Grit

- Try using clear gesso instead of an acrylic ground for pastels. Dilute the clear gesso with water and brush it over any dried paint surface. Wait a few minutes and gently rub it off. Let it dry. The surface will still be gritty enough for drawing.
- Use clear gesso over an unprimed wood panel so the wood shows through. Then draw or paint on top.

16. Drawing

Drawing on top of layers with paint pens, charcoal and pastel is another novel way to add layers to the waxlike paintings. Here you'll learn how to add acrylic ground for working with pastel into paint. The result is a wonderful drawing surface.

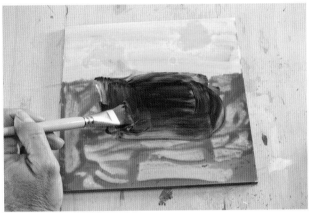

1 Build up the Background
Mix Yellow Ochre with acrylic ground for pastels and apply it to the top portion of the panel. Apply Red Iron Oxide onto the lower portion and blot it with a deli sheet. Let the panel dry. Mix Sap Green, black and Phthalo Green with acrylic ground for pastels and apply it to the center area. Spritz lightly with water to eliminate brushstrokes and let it dry.

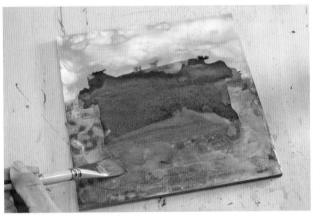

2 Paint the Bottom of the Panel
When dry, dilute a little bit of Iridescent Gold and brush it over the bottom portion of the panel. Let the paint dry.

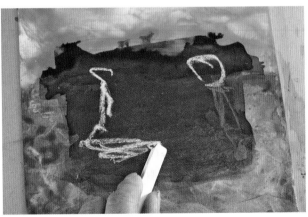

3 Draw on the Panel
Draw on the surface with pastels and paint pens.

4 Apply Final Touches
Spray the panel with workable fixative and let it dry according to the directions on the can. Then, using a palette knife, apply extra-heavy gel molding paste in varying thicknesses to mimic wax. Let it dry.

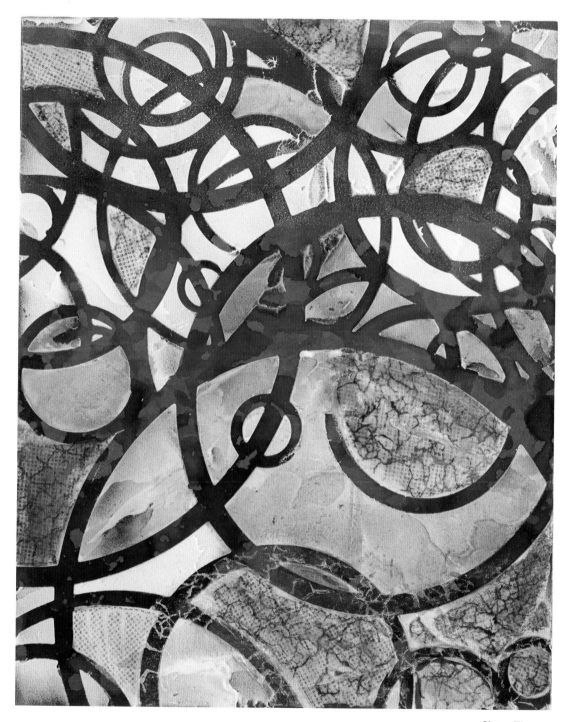

Chaos Theory
10" × 8" (25cm × 20cm)

Materials list

MEDIUMS

faux encaustic medium, light molding paste, polymer medium

PAINTS

Cobalt Blue, Dioxazine Purple, Phthalo Green,
Quinacridone Gold, red, yellow

MISC.

alcohol, Ampersand Aquabord, colored pencils, crackle stamp,
Gampi tissue, painter's tape, palette knife, paper towel, spray
bottle, StazOn ink, stencils, texture plate, workable fixative

Got Gampi?

You can run the Gampi through your ink-jet
printer if you tape it to a carrier paper. Spray
with a workable fixative after printing.

17. Silk Tissue

You can paint, print, transfer, draw, frottage, stamp and then attach this amazingly tough paper. Wonderful and magical silk tissue is one of my favorite materials to use. It is super thin yet strong, and when you adhere it to the painting using polymer medium gloss, the paper goes transparent! This is a wonderful way to get a texture or design in a particular shape by cutting up the paper.

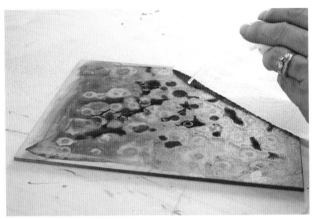

1 Build up the Background
Spray the board with water and let it soak into the surface. Paint with red and yellow and then blend the two colors with water and let dry. Apply a layer of diluted Dioxazine Purple, and while paint is still wet add drops of alcohol onto the board's surface to create an implied texture. Let the paint dry a bit and then gently blot before letting it dry completely.

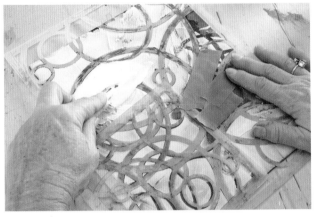

2 Apply Medium Through the Stencils
Use two stencils that have the same design but are different sizes, and arrange one on top of the other. Tape them along the outer edges where it will not interfere with the application of the paste. Then, using a palette knife, apply light molding paste to random areas, keeping some of the background open. Remove the stencils and let the panel dry.

3 Design the Gampi Paper
Place Gampi paper over a texture plate or stencil, and use a colored pencil to create a rubbing of the texture below. Use a crackle stamp with StazOn ink to apply further texture to the Gampi tissue. Spray the tissue with a workable fixative in a well-ventilated area.

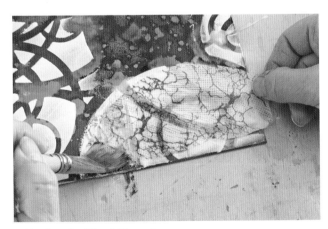

4 Apply Final Touches
Cut the Gampi tissue to size. Using a damp brush, apply polymer medium onto the area where you want to put the Gampi tissue. Place the tissue on the wet surface and gently brush the tissue down. Let it dry. Paint desired areas with diluted Quinacridone Gold, Cobalt Blue and Phthalo Green. Let everything dry before applying the faux encaustic medium of your choice.

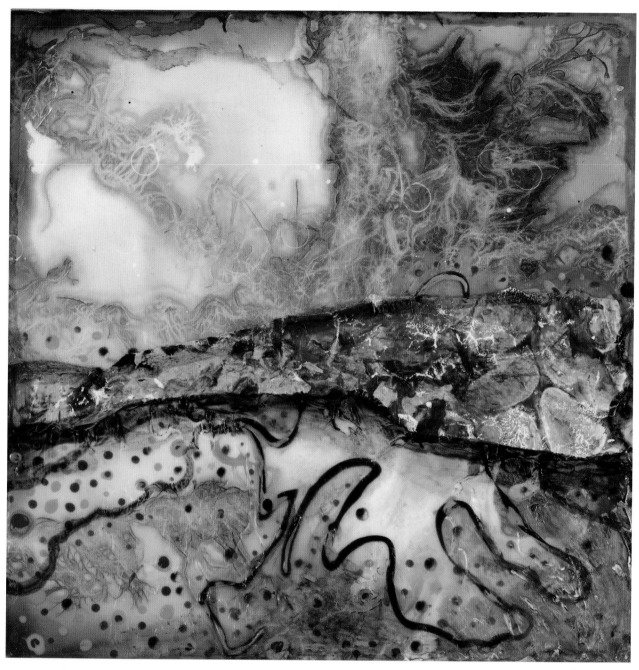

Mountain Lake
8" × 8" (20cm × 20cm)

Materials list

MEDIUMS
clear tar gel, faux encaustic medium, fluid matte medium, soft gel semigloss

PAINTS
black, Cobalt Blue, Lime Green, Phthalo Green, Sap Green, white

MISC.
Ampersand Encausticbord, collage elements, palette knife, plate, spray bottle, squeeze bottle, tape, yarn

Similar Surfaces

You can create a similar surface as the Encausticbord on canvas by using a mixture of Golden Absorbent Ground and soft gel matte.

18. Thick and Thin

Create a layer of implied texture using yarn and then use viscosity, color pours and glazing to achieve rich depth and movement in your painting.

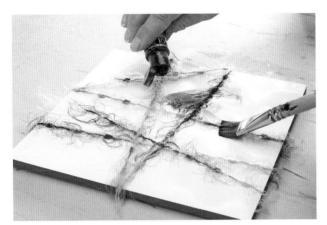

1 Wrap the Yarn Around the Panel
Wrap the yarn around the panel and tape it to the back side to hold it in place. Spray the entire panel with water and drop some Phthalo Green, Sap Green and black onto the panel. (This yarn technique works best with Ampersand Encausticbord.)

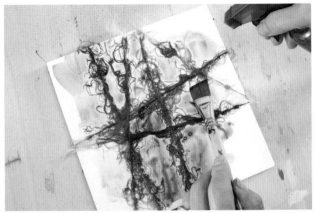

2 Apply More Paint and Remove Excess
Spray the panel with more water and tilt it to mix the paint colors. Pour the excess water onto a plate or another surface. Let the panel dry and remove the yarn.

Alternative Mediums

Try a different medium like Liquitex Pouring Medium to get your paint to flow.

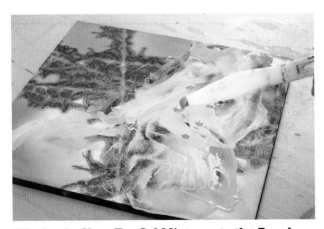

3 Apply Clear Tar Gel Mixtures to the Panel
Mix a drop of clear tar gel with Cobalt Blue and white. Use a knife to spread the mixture across the surface. Then mix Lime Green and Sap Green into clear tar gel, and use your palette knife to drip dots onto the surface.

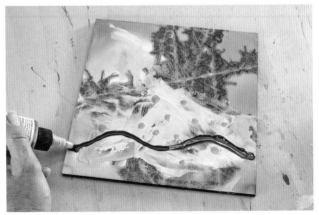

4 Apply Final Touches
Mix soft gel semigloss, fluid matte medium and black paint into a squeeze bottle, then use it to draw a pattern on your surface. Add collage elements using gel and continue to add dots and lines. Let the panel dry, then seal it with a faux encaustic medium.

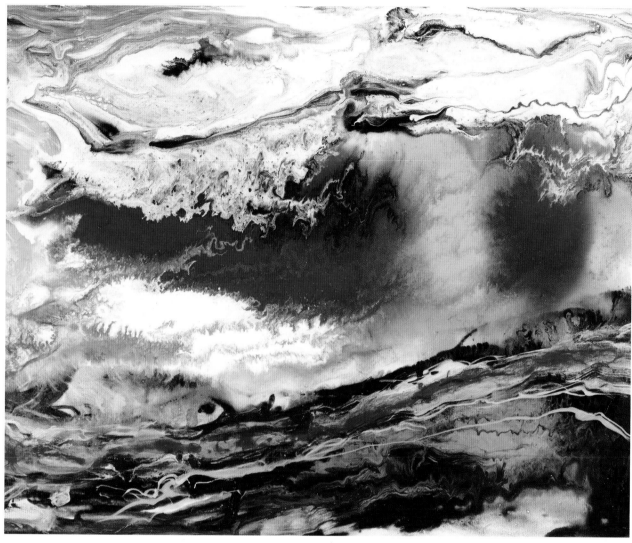

Materials list

MEDIUMS
Floetrol, Matisse Faux Finish & Marbling Gel, Pourable
Faux Encaustic

PAINTS
black, blue, Metallic Aquamarine, Quinacridone Violet,
red, white, yellow

MISC.
Ampersand Encausticbord, plastic mixing containers (or
paper cups), spray bottle, spray varnish

19. Pouring Mediums

Unique pouring mediums can be used to create marbling effects and interesting patterns where two different paint colors meet. When wax is heated, it moves and blends in some very interesting ways. By using paint additives, the acrylic will flow and blend in a manner similar to wax.

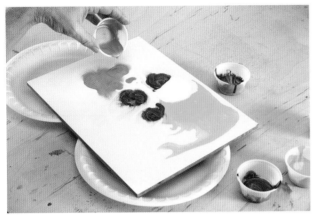

1 Mix and Apply the Paints
Mix Floetrol into separate cups with yellow, blue, black, Metallic Aquamarine and white. Mix a 50 to 50 ratio to begin with, then experiment with different ratios. Mist the Encausticbord with water, then pour the paints.

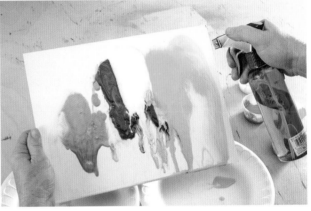

2 Tilt the Panel
Tilt and mix the colors while misting the panel to spread out the paint. Then pour off any extra paint and let the paint dry.

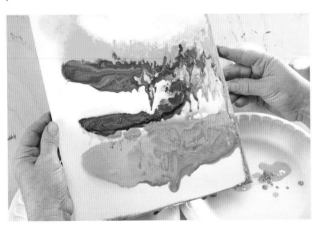

3 Apply Final Touches
Mix red and Quinacridone Violet with marbling gel into two different containers and pour them onto the surface. Let it dry. Use a spray varnish to unify the sheen or apply the faux encaustic medium of your choice.

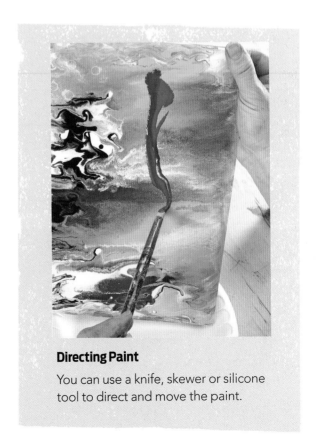

Directing Paint

You can use a knife, skewer or silicone tool to direct and move the paint.

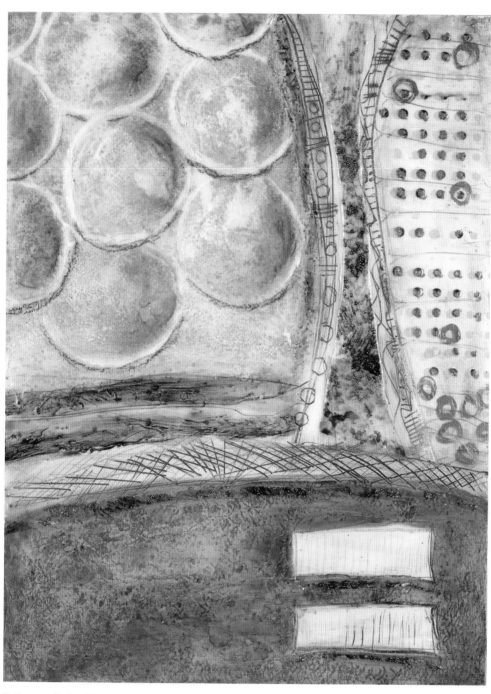

Tesla's Towers
12" × 9" (30cm × 23cm)

Materials list

MEDIUMS
molding paste, polymer medium gloss,
self-leveling gel

PAINTS
Chromium Oxide Green, Copper, Iridescent Bronze,
Quinacridone Crimson, Quinacridone Gold, Sepia,
Zinc White

MISC.
acrylic skins, Ampersand Claybord, dental tool (or
sharp carving tool), fabric, gold leaf pen, paper circles,
sand, satin varnish, spray bottle, towel

What to Use and When to Use It
- If you're going to be using thicker gels to build thick layers, begin with gloss sheens and build up to semigloss or matte. Matte will diffuse whatever is underneath it, and gloss will keep it crisp.
- If you find you have veiled your painting more than you meant too, add a clear gloss layer to bring back some clarity.
- When working with self-leveling gel, dilute it with water to alter the viscosity. If it is applied too thick it will crack.
- To create a soft wax look, apply self-leveling gel and let it dry. Then apply fluid matte medium to push back the sheen.

20. **All** About Layers

It's all about the layers and, more specifically, adding something to each layer to create incredible depth. Your eye can detect very thin layers, so when you add a clear layer, or isolation layer, and then put something on top of that, you get instant depth. You can build many layers, but be sure to make your first layers the most transparent and the final ones more opaque and waxy looking. If you build a lot of layers using opaque mediums, you will obscure your first layers.

Fluid Paint
To make a fluid paint similar to a heavy-body paint, mix the paint into a heavy gel.

Budging Paint
Use alcohol on a towel if paint doesn't want to come off the panel.

1 Mark up the Claybord
The first layer is the unlayer. Spray Claybord with water, and let it soak in. Use a carving tool to carve the Claybord.

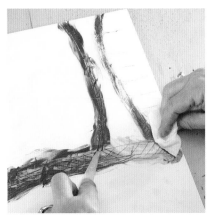

2 Spread the Paint
Use heavy-body paints to rub into the indentations. Let the Quinacridone Crimson, Copper and Chromium Oxide Green paints dry slightly and then wipe the surface with a damp towel.

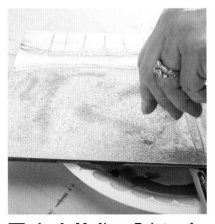

3 Apply Medium, Paint and Sand Onto the Panel
Apply polymer medium and diluted Quinacridone Gold, then sprinkle in some sand. Let everything dry, then brush off any loose sand.

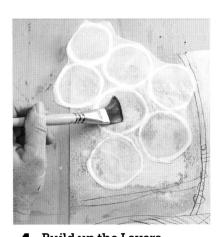

4 Build up the Layers
Apply paper circles with polymer medium gloss. Let it dry. Continue adding new elements to each layer. Use the self-leveling gel as a clear isolation layer between the paint layers to add even more depth. Continue to add layers with drops of paint, markers, skins and glazes.

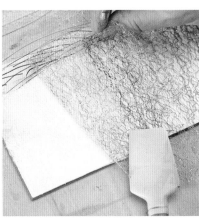

5 Adhere Fabric and Paint
On the lower portion, apply a thin layer of molding paste and press fabric into the wet paste, then remove. When the paste is dry, apply diluted Iridescent Bronze, which will separate into bronze and green. Let it dry. Use the gold leaf pen to draw circles and dots.

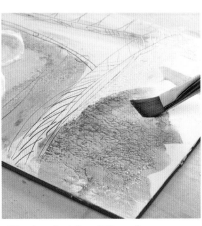

6 Apply Final Touches
Cover the panel with self-leveling gel and let it dry. Use Sepia to add dark areas and Zinc White to highlight areas. (I rubbed it into the paper circles.) Let the paint dry and spray it with a satin varnish or keep the shine of the self-leveling gel.

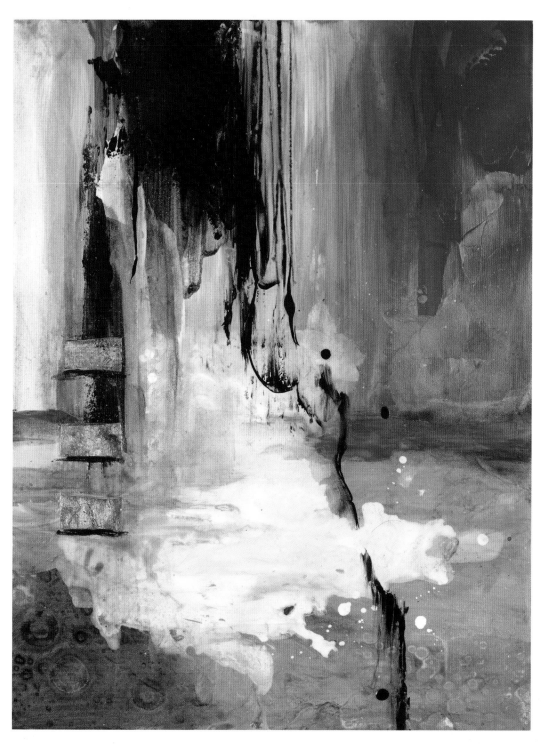

Afterglow
12" × 9" (30cm × 23cm)

Materials list

MEDIUMS
faux encaustic medium, soft gel gloss

MISC.
alcohol, gold leaf, mat board (or paper), painter's tape, palette knife, plastic, scissors, spray bottle, spray varnish (or gold leaf sealer), wax paper

Limitless
Cut your gold leaf into hearts, stars or other designs—you're not limited to strips.

21. Metallics

Iridescent, interference and metal paints add *wow* and shimmer to your acrylic paintings. Interference paints create a color shift when applied over a dark color. Iridescents glimmer, and some of them actually contain metals, such as the copper paint. When applying a gold leaf skin (or cut pieces) to a painting, you can achieve a glow instead of a glimmer by blending a faux encaustic medium on top.

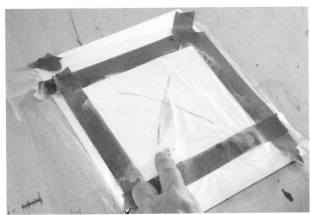

1 Prep for Gold Leaf Application
Take a piece of plastic and cut out a square. Tape the plastic onto a piece of paper or mat board. Use your palette knife to apply a thick, medium layer of soft gel onto the surface, then let it dry completely.

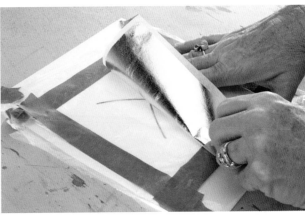

2 Cut out the Wax Paper
When the medium is completely dry, it will go from white to clear. Get the gold leaf, a spray bottle of alcohol and a piece of wax paper. Line up the gold leaf with the wax paper to ensure the wax paper is cut a little larger than the leaf.

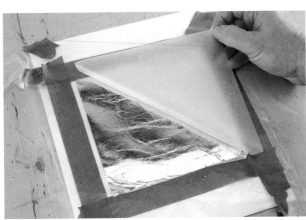

3 Adhere the Gold Leaf
Mist the dry gel layer with alcohol. Let it sit for a moment and then rub it into the gel. The gel should be tacky, not slippery. Pick up your gold leaf by placing the wax paper over the gold leaf and rubbing the top of the wax paper to create friction. The gold leaf will stick to the wax paper. Place the leaf onto the tacky gel, and press down on the wax paper before removing it. Remove the wax paper and gently press down to ensure adhesion.

4 Apply Final
Wait about 20 to 30 minutes to make sure the gold leaf is glued on. Spray it with a metal leaf sealer, an MSA spray varnish or a liquid gold leaf sealer, if desired. When dry, peel off the gold leaf from the plastic and cut off the taped edges. Adhere the gold leaf skins to the painting using soft gel gloss. Finish the painting by applying a faux encaustic medium.

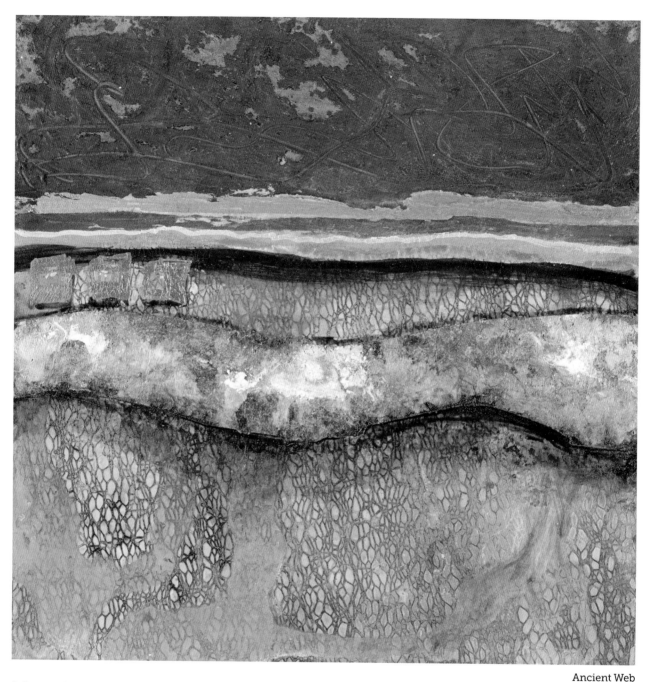

Materials list

MEDIUMS

faux encaustic medium, gel medium, patina solutions

PAINTS

copper reactive paint, Phthalo Green, Phthalo Turquoise, Sepia, white

MISC.

Ampersand Encausticbord, brush, collage elements, gold leaf pen, iron surfacer and rust solution, open-weave fabric, Perfect Pearls pen, Perfect Pearls powder, spray bottle, spray varnish

Perfecting Patina Projects

• Try different types of adhesive pens and adhesive stamp pads for the pigment powders.
• Reactive metallic paints come in different metals, and patinas come in a variety of colors.
• Let the patinas run off the panel and onto deli sheets. When the sheets dry, they make beautiful collage papers.

22. Patinas

Rust, patinas and metallic pigment powders can add interest and texture to your art. If the rust and patina layers are thick enough, and another layer of gel or medium is added, you can achieve a great waxlike look.

1 Mist the Board and Apply the Fabric

Spritz the Encausticbord surface with water, and rub the water in. Place the fabric onto the damp surface. Apply drops of Phthalo Green and Phthalo Turquoise, Sepia and white. Mist the surface with water and use your brush to move the paint around. Let it dry, then remove the fabric.

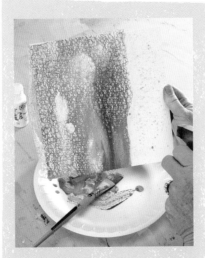

Handy Plates

Have a plate handy to catch the extra paint.

2 Apply Solutions

Use a kit of iron surfacer and rust solution along with copper reactive paint and green patina solution. Mix the iron surface well, and apply a layer. It must dry completely before you proceed.

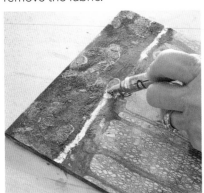

3 Apply Paint, Patina Solutions and Gold Leaf Pen

Apply the copper reactive paint in certain areas. Leave some of the iron exposed. Apply the rust solution and the patina solution over the iron solution while the copper paint is still tacky. Tilt the panel so the patina solution moves around. You will see rust and patina begin to develop. Let it dry completely, then use a gold leaf pen to add detail.

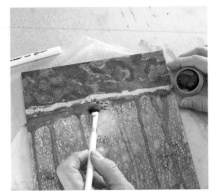

4 Add Adhesive and Powder

Use a Perfect Pearls medium pen (adhesive) to draw on the surface and add Perfect Pearls powder on top of the adhesive. Use a soft brush to brush the extra powder onto a sheet of paper so you can return it to the container.

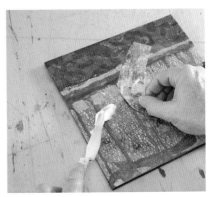

5 Apply Final Touches

Add collage elements using gel medium and more gold leaf or Perfect Pearls, as desired. When everything is dry, use a spray varnish to seal the piece. Then use a faux encaustic medium of your choice.

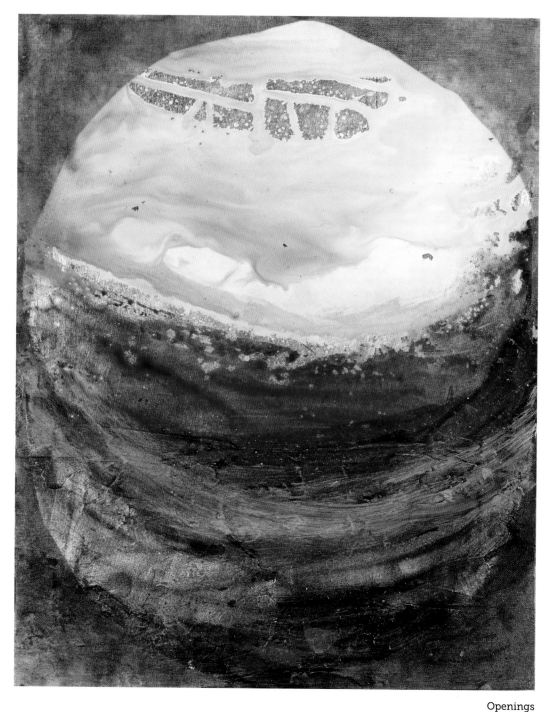

Openings
10" × 8" (25cm × 20cm)

Materials list

MEDIUMS
acrylic glaze satin, fluid matte medium, polymer medium
gloss, regular gel semigloss

PAINTS
blue, Red Iron Oxide, Sepia, violet

MISC.
ExtravOrganza silk sheets, gold leaf, gold leaf adhesive,
panel, scissors, soft cloth, spray adhesive, spray varnish, wax
paper, workable fixative

23. **Matte** and Shiny Leaf

Matte gel and silk fabric over metallic leaf demonstrates how a matte material pushes back the shine of the gold leaf. For this project you'll work with both smooth and textured surfaces prior to adhering the gold leaf.

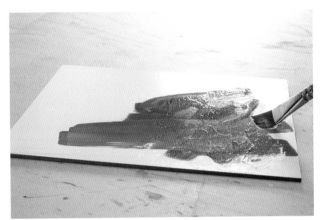

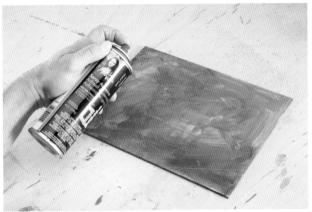

1 Apply the Base Medium and Color
Apply a gel medium to the lower portion of the panel to create texture, and leave the upper half smooth. Let it dry. Paint the entire surface with Red Iron Oxide, and let it dry. The Red Iron Oxide is a base color that will show through any cracks or openings in the gold leaf. This is the traditional color to use with gold leafing.

2 Apply the Adhesive
Spray an adhesive, or brush a fluid adhesive, onto the surface. Follow the directions on the container.

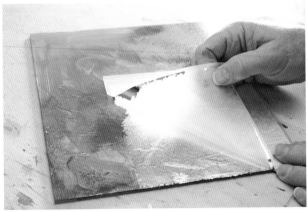

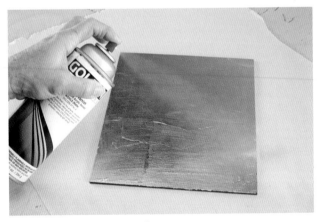

3 Adhere the Gold Leaf
If you used a spray adhesive, then immediately apply the gold leaf, pressing it down with wax paper. If you used a fluid adhesive, then wait until it changes from milky to transparent before you apply the gold leaf. Slightly overlap your gold leaf sheets. Remove the wax paper and use a soft cloth to rub the leaf down. Brush off any loose pieces.

4 Seal the Gold Leaf
Spray outside or in a well-ventilated area with a mineral spirit acrylic aerosol varnish or leaf sealant. Let it dry.

Golden Gels and Pastes

Try using different pastes and gels over the gold leaf, but let everything dry for several days before handling the art.

5 Add Paint Texture
Mix blue paint into fluid matte medium, then add water and float it onto the surface. It will bead up in areas. (If you don't want it to bead up, add less water and more medium.) Adjust the viscosity to increase the coverage.

6 Apply the Gloss and Paint Mixture
Mix violet into polymer medium gloss, and brush it onto the textured surface. Then let it dry.

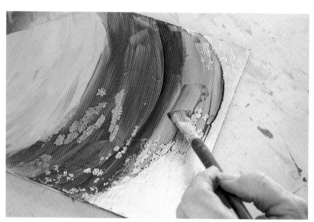

7 Adhere the ExtravOrganza
Cut your Extravorganza to size, and apply fluid matte medium to the area where the ExtravOrganza will go. Lay the printed silk (ExtravOrganza that's been printed on an ink-jet printer and sprayed with a workable fixative to set the ink) onto the wet medium and gently brush it down. Avoid overbrushing or you may smear the ink. Let it dry. Keep some areas shiny and some matte to create different looks.

8 Apply the Final Touches
Glaze with Sepia mixed into acrylic glaze satin or fluid matte medium to adjust the sheen in desired areas.

ExtravOrganza

ExtravOrganza is a fabric mounted onto a carrier sheet that is ready for printing. I printed on an ink-jet printer and sprayed with Krylon workable fixative. It helps to increase saturation when printing because a lot of the ink goes through the fabric.

Golden Ideas

- Experiment with printed fabrics.
- Try gold leaf pens.
- You may gently sand the painted leaf surface but only after you let the paint bond with the gold leaf for a week or more.

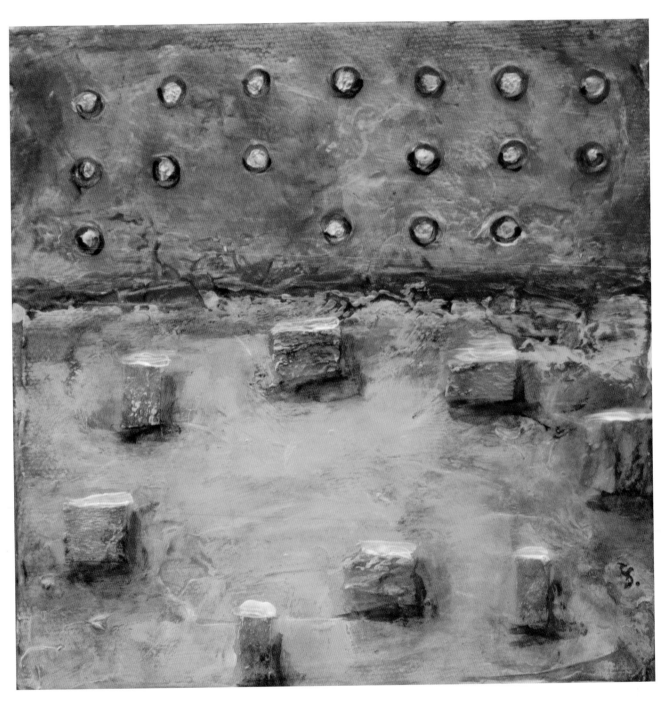

Writing on the Wall
6" × 6" x 2" (15cm × 15cm × 5)

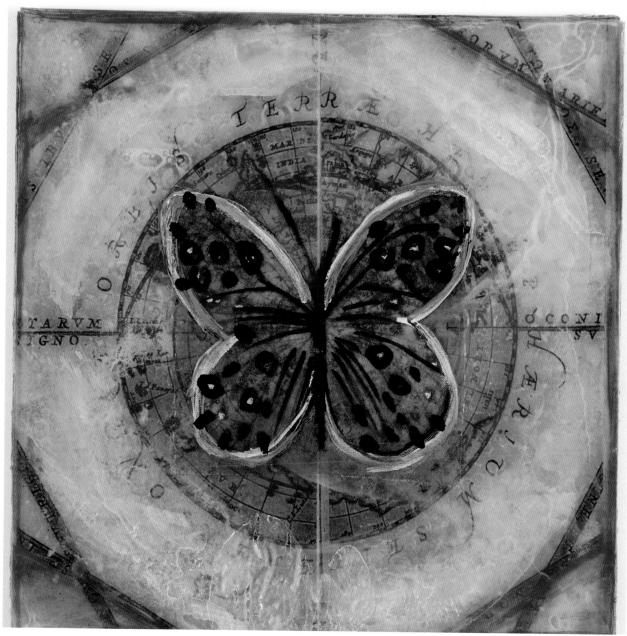

Terra
6" × 6" (15cm × 15cm)

Materials list

PAINTS
high-flow white, Red Iron Oxide, yellow

MISC.
alcohol, paint pens, panel, spray bottle, vinyl, water-slide decal paper, workable fixative

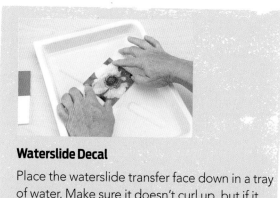

Waterslide Decal
Place the waterslide transfer face down in a tray of water. Make sure it doesn't curl up, but if it does, press it down gently.

24. Vinyl

Working on vinyl creates instant layers because it's transparent. It can then be adhered to a panel to create even more depth. High-flow acrylic paints and specialty paint markers make it easy to write on and to create layers on the vinyl. Use ultramatte medium or decoupage matte on vinyl for transfers, or even add collage on both sides!

1 Build up the Background Layers
Paint the panel with Red Iron Oxide, and let it dry. Mix yellow and white, then apply the mixture to the surface. Drip alcohol drops onto the wet paint to create implied texture.

2 Create a Water-Slide Decal
Print an image onto a water-slide decal paper and attach it to vinyl.

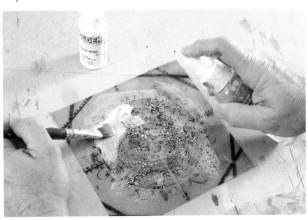

3 Apply Paint
Apply diluted white paint and spritz with alcohol to create an implied texture. Attach vinyl to panel with gel or decoupage matte.

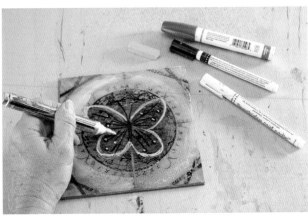

4 Apply the Final Touches
Add butterfly and use paint pens to accentuate the butterfly and image lines.

I Spy...
Vinyl can be found at fabric stores. It's usually used to sew covers for outdoor furniture.

Prevent Pulling
After the vinyl has been applied to the panel, let it dry and add a small amount of gel around the edges to ensure that the vinyl doesn't pull away from the panel.

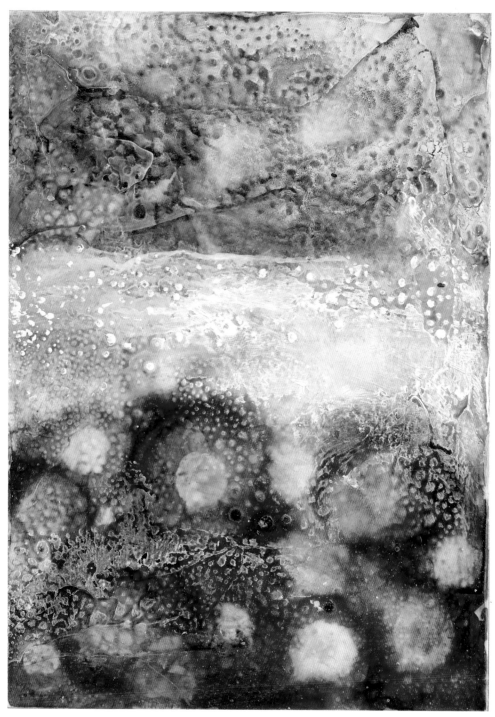

Hot Stuff
7" × 5" (18cm × 13cm)

Materials list

MEDIUMS
heavy gel matte, shellac

PAINTS
blue, white

MISC.
alcohol, Ampersand Claybord, alcohol inks (blue, green, magenta, orange, purple, white, yellow), paper towel, torch or matches

No Shellac?

If you don't have any shellac, then latex house paint can be burned using a torch or heat gun to create a different type of bubble effect. Always take precautions.

25. Shellac

Alcohol inks and shellac on Claybord can be torched to create a very interesting texture. When a matte gel is applied on top, it integrates the texture with the background and allows paint to be added on top. This creates a look similar to Encaustic dry-brush or accretion.

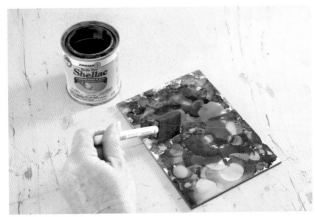

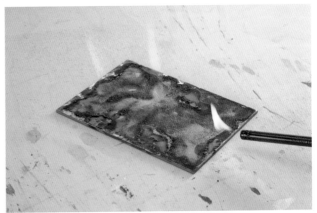

1 Apply Ink, Alcohol and Shellac
Apply alcohol inks to the Claybord. Drop the inks directly from the bottle, then drip some alcohol onto the surface. Let it dry. Apply a generous amount of shellac to the surface.

2 Ignite the Shellac
After appling shellac to the surface, immediately ignite it with a match or a torch. (Do this outside in an area that is not flammable. Concrete is a good choice.) The flame will burn until the shellac is gone. Let it cool. Then apply a layer of heavy gel matte. Let it dry completely.

Best Results

This process with alcohol inks gets the best results when applied onto Claybord. Don't try this on canvas paper.

Burnt Out?

If there is still shellac that hasn't burned, wipe it off with a damp towel and let the surface dry completely before coating it with gel.

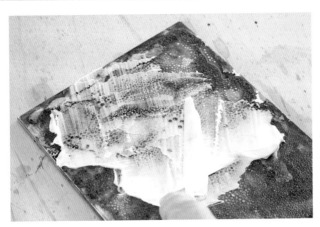

3 Apply Paint
When dry, brush on some white paint and rub it into the recesses. Wipe off the surface and do the same with the blue paint.

4 Apply the Final Touches
Continue to build up the layers of gel and paint until you've created a surface that looks like wax.

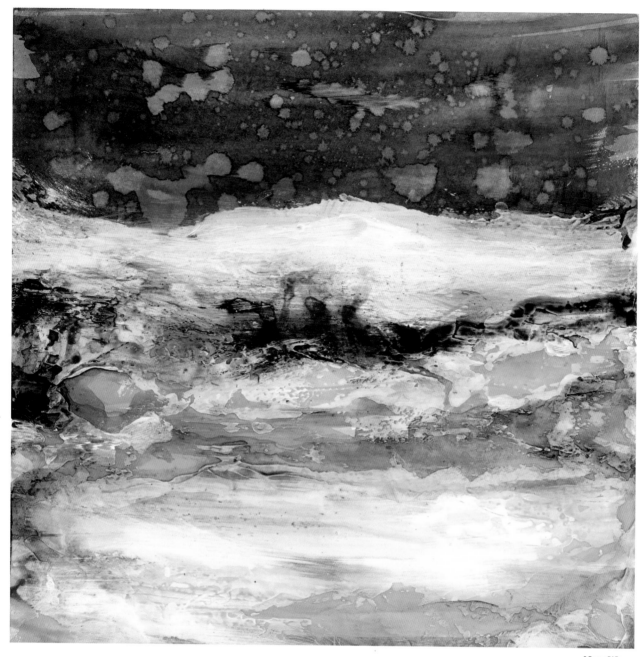

<div align="right">

New Wave
6" × 6" (15cm × 15cm)

</div>

Materials list

MEDIUMS
faux encaustic medium (optional), fluid matte medium, Venetian plaster

PAINTS
Lime Green, Magenta, Payne's Gray, Phthalo Green, yellow

MISC.
Ampersand Claybord, green scrub sponge, palette knife, paper towel

26. **Venetian** Plaster

Venetian plaster may be used as a layer within a painting or as the entire surface for a painting. The trick to working with plaster is to apply it in thin layers—use a very diluted paint on top and seal it when completely dry. Here Venetian plaster is applied as a layer.

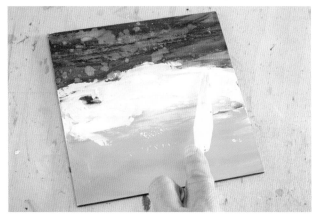

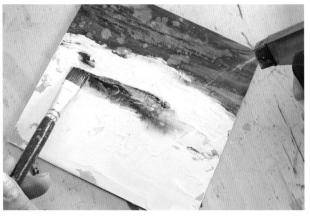

1 Build up the Background Layers
Paint the background yellow and let it dry. Apply Payne's Gray and sprinkle water drops onto the wet paint. Let the paint dry slightly before blotting some of it off so the yellow comes through. Apply Lime Green and Phthalo Green to the lower portion. When dry, use your knife to apply a thin layer of Venetian plaster across the middle area. Let it dry.

2 Add Diluted Paint Over the Plaster
Add some diluted Magenta paint to the Venetian plaster layer, then let it dry.

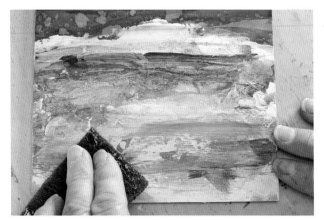

3 Build the Layers
Use a damp scrub sponge to remove some plaster, then apply fluid matte medium to seal the plaster. Continue to add and remove plaster and paint layers until satisfied. Let the panel dry completely, then seal with a diluted faux encaustic medium of choice or diluted fluid matte medium.

Beautiful Burnish Instead of a Medium
Use a piece of craft paper to burnish the surface. Press hard when rubbing—it compresses the plaster and creates a sheen similar to wax.

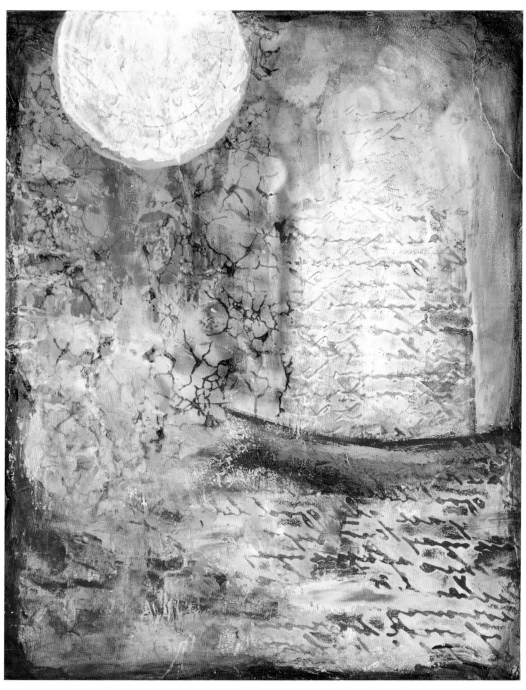

Words of Wisdom
10" × 8" (25cm × 20cm)

Materials list

MEDIUMS
fluid matte medium, Venetian plaster, Venetian plaster seal

PAINTS
Cobalt Teal, Payne's Gray, Quinacridone Burnt Orange, Red Iron Oxide, Sepia, white, yellow

MISC.
alcohol, Ampersand Claybord, deli sheet, foam stamps, skewer, soft cloth

Did You Know?
Acrylic paint needs to be diluted with water to break down the plastic binder so it will absorb into the plaster.

27. **More** Venetian Plaster

Venetian plaster becomes the surface instead of just a layer. When creating a painting with plaster, apply multiple thin layers to build the surface. If applied too thick it will crack.

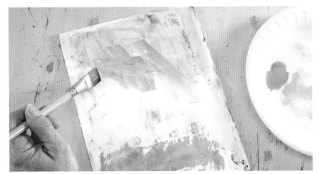

1 Build the Background Layers
Begin with a painted background of Payne's Gray and alcohol drops, but keep the paint layer thin. Apply a layer of plaster and let it dry. Apply diluted Cobalt Teal on top and Quinacridone Burnt Orange on the bottom.

2 Reveal and Seal
Rub some paint off to reveal the underlying color. Seal with diluted fluid matte medium.

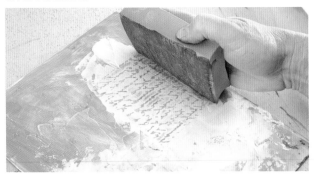

3 Stamp Onto the Plaster
Apply untinted plaster in random areas and let it dry. Then use a stamp and Red Iron Oxide to stamp writing into the plaster. Remove some areas of the stamped ink by rubbing off the plaster.

4 Create a Plaster Deli Sheet
Apply plaster very thinly onto a deli sheet and let it dry. Then apply yellow and white paint. Scratch into the dry plaster and paint using a skewer, then cut it into a half-circle shape before attaching it to the panel with fluid matte medium.

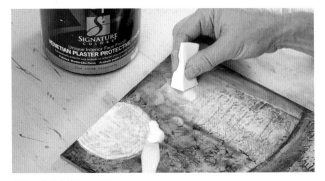

5 Add More Paint
Apply Sepia around the edges of the panel to further enhance the aged look.

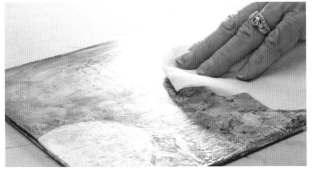

6 Apply the Final Touches
When completely dry (one to two days), seal with a Venetian plaster seal. When the seal is dry, burnish it with a soft cloth to get a sheen similar to wax.

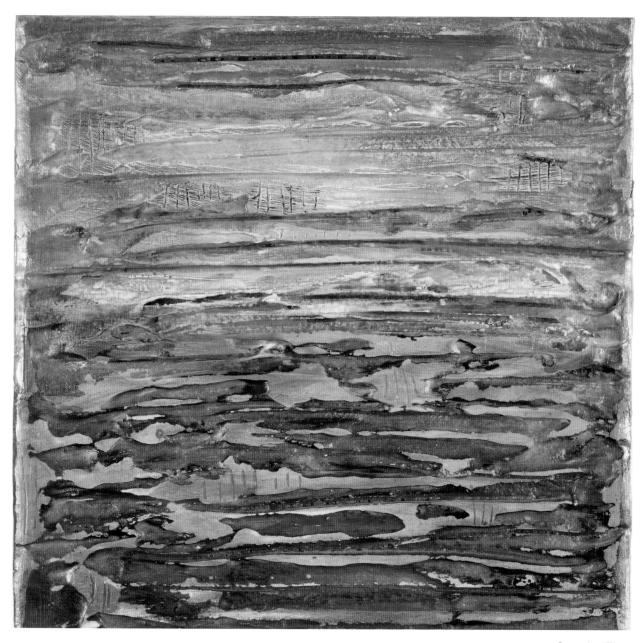

Counting Time
8" × 8" (20cm × 20cm)

Materials list

MEDIUMS
plaster of Paris (6 ounces [175ml] plaster to 3 ounces [90ml] of water), spreadable faux encaustic

PAINTS
DecoArt Metallic Lustre orange paste, Metallic Bronze, Metallic Gold

MISC.
clay trimmer, craft stick, craft knife or dental tool, mixing cups, natural wood panel, painter's tape, sandpaper, spoon, spray bottle

Plaster Patterns

Try pressing found objects into the plaster while it's wet to create unique patterns.

Paint Transformations

Make the fluid paint into heavy-body paint by mixing the fluid paint into a heavy gel.

28. Plaster of Paris

Plaster of Paris is a different animal than Venetian plaster. Once you mix the powder with water, a chemical reaction begins that you cannot stop. You have limited time to work before it hardens, but you can apply it thickly and shape it while it is still wet. You can carve it after it's dry, too. It is a bit fragile, but sealing it helps stabilize it. It takes on the look of wax although it doesn't have the translucency of wax. Adding acrylic layers, however, will result in an encaustic look.

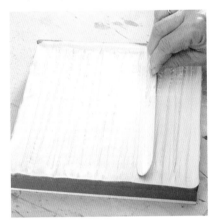

1 Set the Plaster and Create Lines

Tape the sides of the panel so there is a slight lip coming up over the edge. Thoroughly mix plaster of Paris: Two parts plaster and one part water. Pour the plaster onto the panel and use a craft stick to spread the plaster. Tap the panel on the table to release air from the plaster, then let it set up for a few minutes. Use the wood stick to press lines into the plaster. Let it cure.

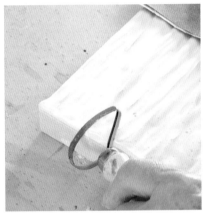

2 Trim, Sand and Paint the Plaster

Remove the tape and trim the plaster edges with a clay trimmer, then sand down any sharp any peaks. Lightly mist the surface with water, then apply metallic paints and rub in.

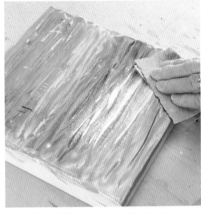

3 Sand Down the Painting

Apply another layer of paints, rub off or even sand down to reveal new plaster and add another color.

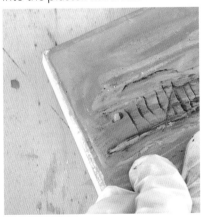

4 Scribe Into and Paint the Plaster

Use a knife or dental tool to carve designs, lines and other marks into the plaster. Then use a heavy-body paint to rub into the marks.

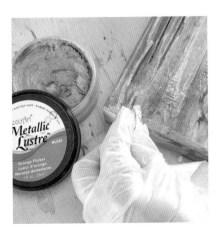

5 Apply Lustre Paste

Apply some DecoArt Metallic Lustre paste and burnish the surface using a spoon.

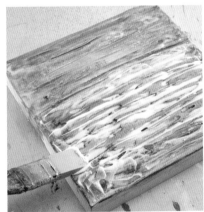

6 Seal the Painting

Seal with spreadable faux encaustic to finish.

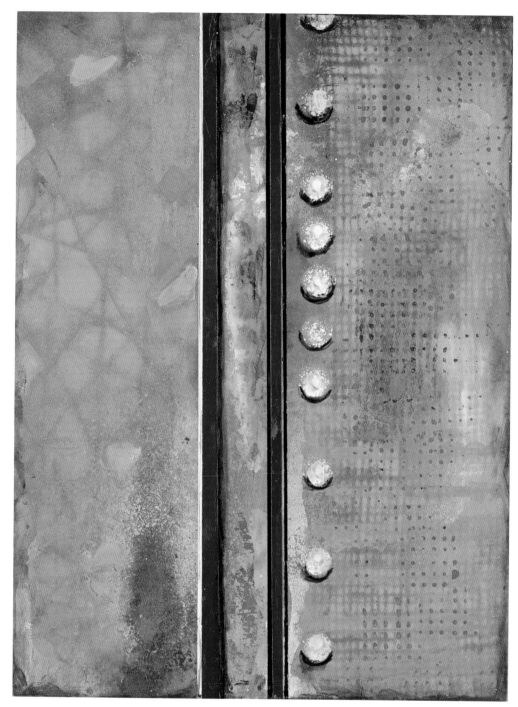

Materials list

MEDIUMS
faux encaustic medium, light molding paste, soft gel gloss

PAINTS
Cobalt Teal, Copper, Dioxazine Purple, Magenta, paint pens
(black and white), spray paints (blue, copper, yellow), white

MISC.
burlap fabric (open-weave material), deli sheets, foam brush,
foam pouncer, panel, place mat (stencil), tape

29. Masks

Masks can be made using tape, stencils, fabrics and other textured objects. By using different types of paint and working with viscosity, you can create implied depth. Spray paint applied through a thick material with an open weave will create a soft edge. A wet paint applied over tape will render an uneven edge, and gel and paint applied over the tape will create a hard edge. The soft edges tend to recede, and the sharp edges come forward.

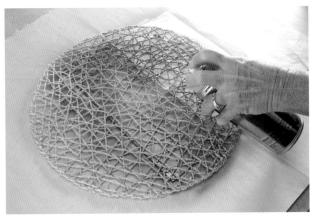

1 Spray Through the Place Mat
Spray paint an area of the panel with copper. Block off some areas with deli sheets and spray again with blue spray paint. Mask the right side with deli sheets and put the place mat over the left side. Spray with yellow. Reverse the mask, put the burlap over the right side and spray with yellow.

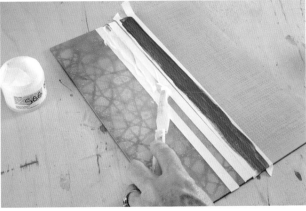

2 Apply Tape for Added Effect
Apply tape to a section. Mix Copper and Magenta with a little water, and paint over the taped area. Remove the tape and let it dry. To get a crisp edge, apply tape to the surface and rub it down. Apply some soft gel gloss and immediately put the paint on top. Let it dry, then remove the tape. Make more stripes using gel and Dioxazine Purple.

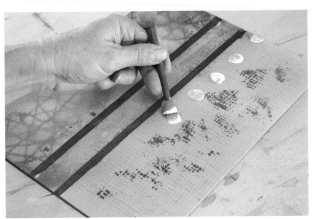

3 Apply Final Touches
Mix Magenta with light molding paste and apply it with a foam brush to a piece of burlap: Use this burlap as a stamp onto the right side of the panel. Use a foam pouncer to apply Cobalt Teal and then white paint. Then use paint pens and a straightedge to make black and white lines. Apply the faux encaustic recipe of your choice.

More Masking Magic...
- Try using a stencil and a foam roller to get a similar effect as the spray paint used here.
- Use a makeup sponge to apply paint through the stencil.

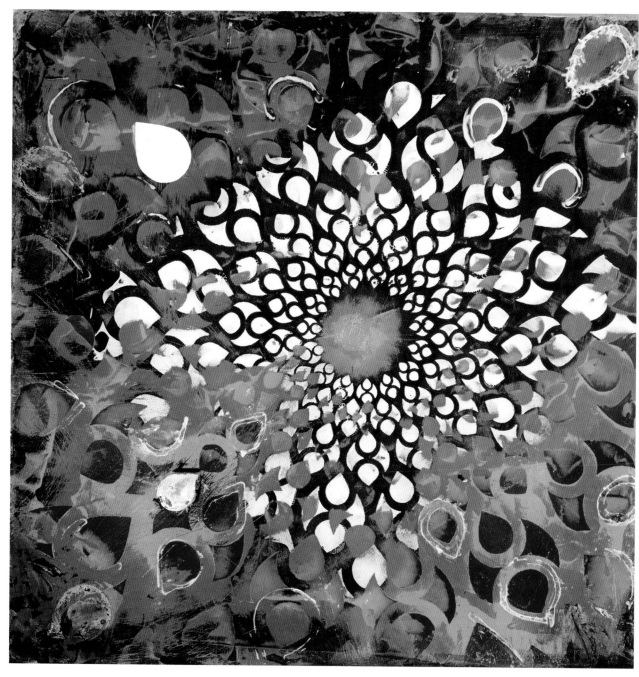

Sol
8" × 8" (20cm × 20cm)

Materials list

MEDIUMS
hard molding paste

PAINTS
black, Gold Gesso, Magenta, orange, purple, white

MISC.
panel, sandpaper, stencils (two different sizes), tape

Build the Layers

- Try different grits of sandpaper to leave alternative marks from the sanding.
- Try embedding crackle paste through a stencil as one of the layers.

30. **Build** a Painting

Acrylic is difficult to sand because it becomes tacky with the heat from the friction of sanding. Hard molding paste is the acrylic to use for sanding. It won't gum up your sandpaper, but it is a lot of work. One option is to use an electric sander—it's much easier. The trick is remembering your first layers and colors because you'll be covering them up with subsequent layers. The fun is in the unexpected reveal!

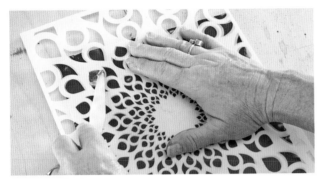

1 Apply Molding Paste Through a Stencil
Paint the panel with Gold Gesso and let it dry. Then apply purple mixed with hard molding paste through a stencil. Remove the stencil and let the molding paste dry. Drying may take up to a day, depending on conditions.

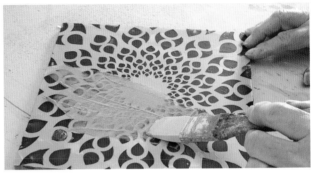

2 Apply Another Layer of Stencilling
Apply orange mixed into hard molding paste over the entire panel and let it dry.

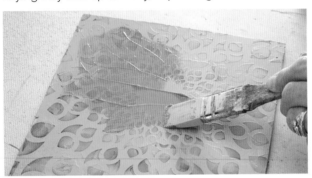

3 Spread Molding Paste Over the Panel
Spread molding paste mixed with Magenta over the entire panel and let it dry.

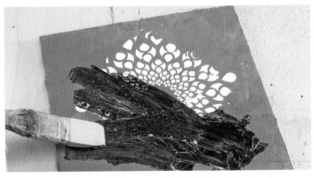

4 Apply Stencilling and Molding Paste
Apply hard molding paste mixed with white through a small stencil. Let it dry. Apply black-purple mixed with hard molding paste over the entire surface and let it dry.

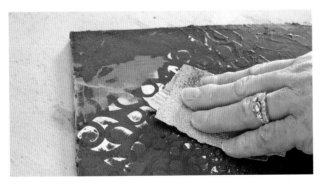

5 Sand the Panel
Sand back to reveal the underlying layers. Develop the painting by sanding back more in some areas, revealing different colors and patterns.

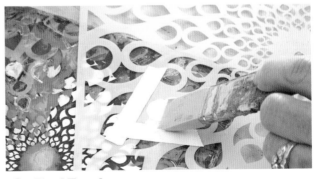

6 Final Touches
Apply molding paste with white through a stencil in select areas. Tape off the stencil so only one petal, or design, at a time may be applied. The final sheen is already matte, so don't apply a faux encaustic medium.

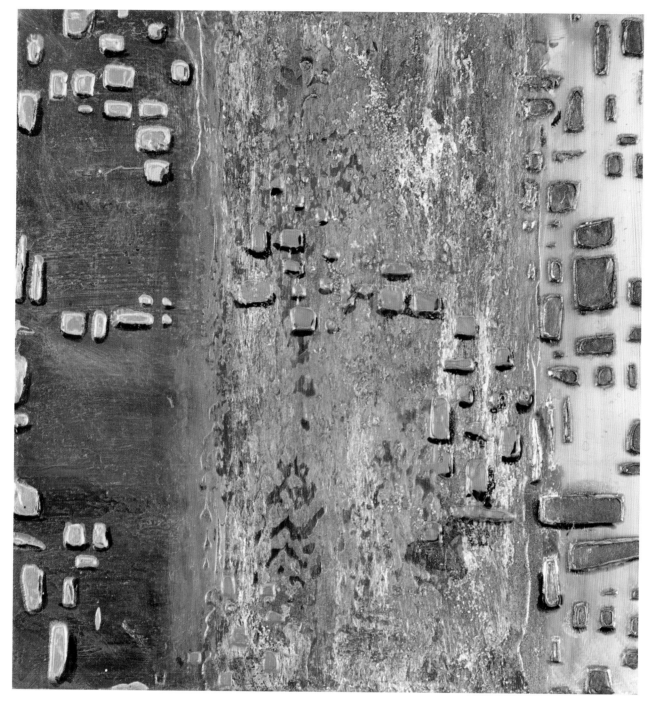

Materials list

Reflections
6" × 6" (15cm × 15cm)

MEDIUMS
faux encaustic medium, heavy gel

PAINTS
Charcoal, gold, Iridescent Green, red, silver, violet, white

MISC.
cast acrylic mirror surface, paper towel, palette knife, spray bottle, stencil

Mirror, Mirror

Use transparent and iridescent paints to create a glow, and apply opaque paints through stencils to achieve a shadow effect from the mirror. Vary the amount that you veil the mirror for an additional effect.

31. **Acrylic** Mirror

Paint on mirrored cast acrylic and use the reflection to increase the depth and enhance the glow. This is one of my favorite surfaces to paint on, and I've even made sculptures with it! Use a metallic paint to diffuse the reflective quality. When you use a stencil with pastes and gels, the depth of the images creates a shadow on the surface.

1 Paint the Mirror
Remove the plastic covering of the mirror. Dilute silver or white paint with water and brush it over the surface of the mirror.

2 Create Implied Texture
Create implied texture by misting water drops onto the damp paint and gently blotting. Let it dry.

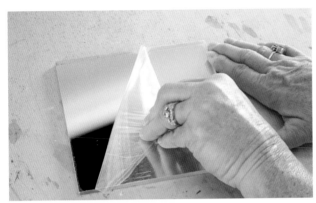

3 Apply Paint Through a Stencil
Apply Charcoal paint mixed with gel through a stencil.

4 Add More Layers
Mix violet and white paint with the gel and, using your knife, drag some of the paint over the center area of the surface.

5 Apply Final Touches
Paint Iridescent Green on a portion of the panel and let it dry. Drag more colors over the middle section, and add gold mixed with gel through the stencil in another section. Let dry. Drag some red paint over the purple and then add more gel and paint through the stencil in the center area. Let it dry. Finish the painting with the faux encaustic medium of your choice.

Santa Fe Home
10" × 8" (25cm × 20cm)

Materials list

MEDIUMS
clear crackle, polymer medium, soft gel semigloss, spread-able faux encaustic

PAINTS
gold, Phthalo Green, red, Sienna, white

MISC.
beads (drilled stone), cast acrylic panel (Plexiglas), collage elements, craft paper, drill, fine-grit sandpaper, laser print transfer, palette knife, spray bottle, wire

Perfect Plexiglas Imperfections

Mask off sections of the Plexiglas and sand with a fine-grit sandpaper to create a pattern in the Plexiglas—or try scratching marks into the Plexiglas and rubbing heavy-body paint into the crevices.

32. **Painting** on Plexiglas

Cast acrylic has many brand names like Lucite and Plexiglas. The cast acrylic will bond with acrylic paint, unlike wax which just sits on the surface. Transfers, paint, collage and fabrication are covered here. My previous book, *Alternative Art Surfaces,* contains many ideas for working on cast acrylic, but here we want to have it look like wax.

1 Place the Transfer in the Medium
Remove any protective plastic or paper covering the cast acrylic. Using a knife, apply soft gel semigloss to the Plexiglas where the transfer will go. Lightly mist the face of the paper with water, and place the laser image face down into the wet gel to make the image as smooth as possible. If you don't mist with water, wrinkles will occur—and will add texture. Let it dry. (This method is for laser images only.)

2 Remove the Paper Layer
Scuff the back of the paper with sandpaper to rough up the surface. Spray with water and give it a few minutes to soak in. Begin by rolling the paper off with the pads of your fingers. Continue to remove paper. Do not add more water; just dampen your hands to remove the paper. A piece of craft paper also helps to remove the last layer of paper.

3 Add Layers of Paint to the Back
Mix gold with polymer medium to create a glaze, and apply it to the back of the transfer. Do the same with the red. Let it dry. Mix a small amount of Phthalo Green into the clear crackle, and apply it to the area of the Plexiglas without the transfer. Let it dry.

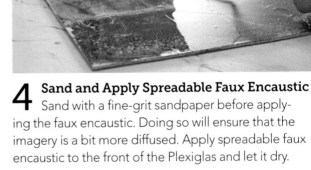

4 Sand and Apply Spreadable Faux Encaustic
Sand with a fine-grit sandpaper before applying the faux encaustic. Doing so will ensure that the imagery is a bit more diffused. Apply spreadable faux encaustic to the front of the Plexiglas and let it dry.

5 Apply the Final Touches
Apply your collage elements with the faux encaustic. When dry, drill a hole and wire your beads through the hole. Apply a coat of white paint to the back to reflect the light back out through the front.

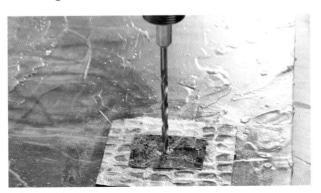

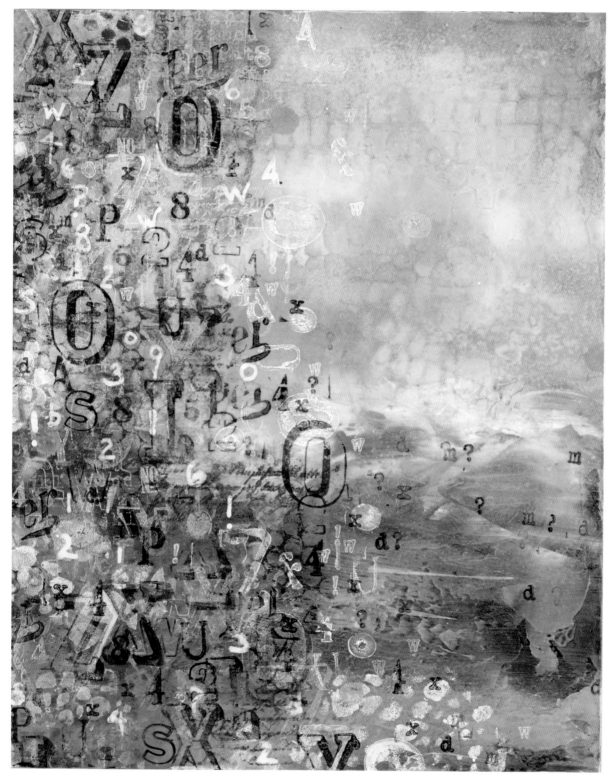

Materials list

MEDIUMS
extra-heavy gel molding paste, light molding paste

PAINTS
Cobalt Teal, Payne's Gray, white, yellow

MISC.
found materials, panel, stamps, StazOn ink
(brown and red), white paint pen

33. Stamping

The best part about this painting is that you can begin with an old painting that needs a do over, or if you're like me and you have panels around for experimental purposes, you can use one of those. By using gels, layering with stamps and veiling with pastes, you can achieve a waxy look.

1 Build up Background Layers
Use a demo panel that has textures and paint on it, or create your own. Here the background colors are Payne's Gray, Cobalt Teal, white and yellow. Add some light molding paste to lighten and smooth some areas. Add white and yellow paint, let dry and then begin stamping. Add a layer of extra-heavy gel molding paste and let it dry. The key to a waxlike look is to build the layers.

2 Stamp Into the Wet Pastes and Gels
Continue adding layers with extra-heavy gel molding paste and more stamps. Go for imperfect stamp impressions. You can use found materials, like packing materials, to press into the wet pastes and gels. Use StazOn ink so the ink doesn't smear and stamp onto the dry pastes and gels.

3 Add the Final Details
Use a white paint pen to draw into some areas for additional detail.

Blurred Lines

Apply stamp cleaner to your stamp, then test the stamp on a piece of paper. Use the stamp on your surface to get a blurred impression.

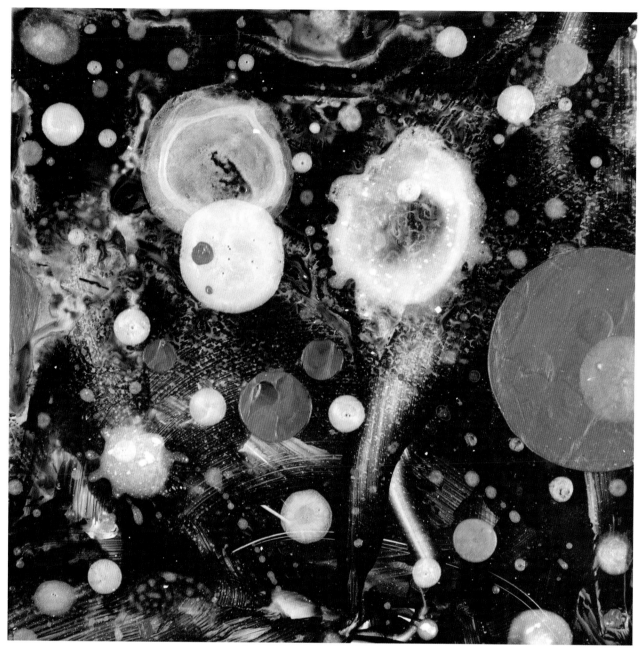

Materials list

MEDIUMS
heavy gel semigloss, pourable faux encaustic, self-leveling gel, spreadable faux encaustic

PAINTS
black, Copper, Interference Blue, Interference Green, Interference Orange, other Interference colors, Payne's Gray

MISC.
Ampersand Claybord panel, eye dropper (pour bottle), foam pouncer, palette knife, paper towel, stencils

Out of This World

Add some glitter or opaque white flakes to this project to take the galactic look even further.

34. **Hard**/Soft Edges

Interference paints really pop over a dark background, and metallic paints mixed in with the gels add a diffused glow. Foam stamps or rollers can create a mottled edge.

1 Create the Background and Blot off the Water
Mix together Payne's Gray and black, then paint onto the surface. Sprinkle some water drops onto the wet paint and while the paint dries, blot off the water drops.

2 Create Splatters, Drops and Other Designs
Dilute some Interference Blue with some pourable faux encaustic and water, then splatter and drop this mixture onto the surface. Swirl the blue paint around with your finger or a brush.

3 Repeat Step 2 With a New Color
Repeat step 2 with Interference Green, then mix another color of Interference paint with the self-leveling gel, and drop a few spots onto the surface. The spots will naturally level out. Tilt the panel to change shapes. Let it dry.

4 Apply Mixtures Through a Stencil
Mix Interference Orange and Copper into heavy gel semigloss. Place your circle stencil in a desired location and using your knife, apply heavy gel semigloss without the paint through the stencil. Hold the stencil in place and then layer the mixed orange gel onto the previous layer. Remove the stencil and clean it.

5 Apply the Final Touches
Try mixing other Interference colors with gel to get more hard edges. Dilute Interference paint with water, and use a foam pouncer to apply paint to achieve a mottled effect. Let everything dry and then coat the entire panel with a layer of spreadable faux encaustic.

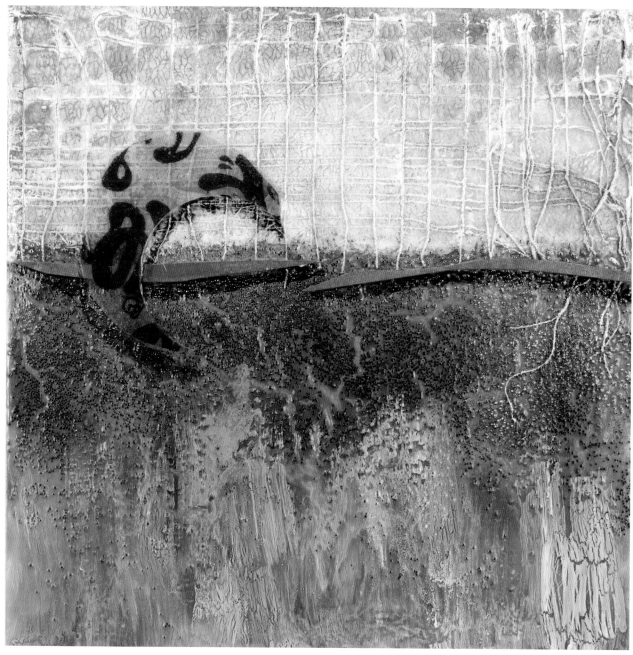

Instant Gratification
8" × 8" (20cm × 20cm)

Materials list

MEDIUMS
black micro beads, DecoArt Media Antiquing Cream, decoupage, Elmer's glue, heavy gel matte, instant coffee crystals, pourable faux encaustic medium

PAINTS
blue

MISC.
Ampersand Encausticbord, cheesecloth fabric, rice tissue paper with strings, spray bottle

35. Mix Ins

Mix ins, like micro beads, glass, mica, tea or instant coffee crystals, are just some of the wild things you can add to acrylics. I mixed instant coffee crystals into glue and even after it was dry, when I painted another layer onto it, it smelled like coffee. I love coffee!

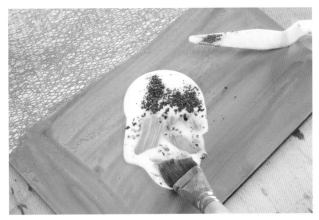

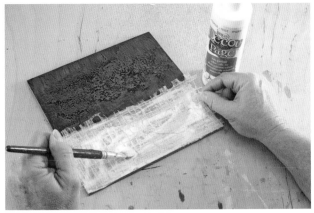

1 Build up the Background and Add Coffee and Beads

Mist the panel with water and place the cheesecloth onto the wet surface. Using your brush, apply a diluted paint on top of the cheesecloth and paint the lower portion blue. When the paint is dry, remove the cheesecloth or fabric.

On the lower portion of the panel, apply pourable faux encaustic medium. Using a brush, mix instant coffee crystals into the faux encaustic until dissolved. Sprinkle beads onto the wet faux encaustic medium and let it dry.

2 Adhere Rice Paper

Apply decoupage onto the upper portion of the Encausticbord and gently place the rice tissue paper on it. Then gently brush it and let it dry.

Organic Inspiration

Try incorporating instant tea, tea leaves, coffee grounds or mica chips, glitter or beads into your next painting.

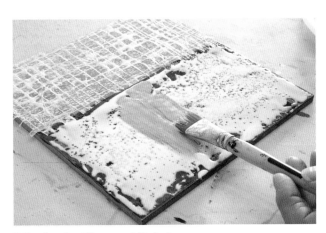

3 Apply Glue and Paint

Apply Elmer's glue and, while the glue is wet, float paint on top of it. Let it dry for a crackled effect. The cracks will occur in the direction of the brushstrokes.

4 Apply the Final Touches

Add antiquing medium on top of the sealed paper. Wipe off as much or as little as you like. Attach the collage elements with the heavy gel matte. When satisfied, seal the entire surface with pourable faux encaustic medium.

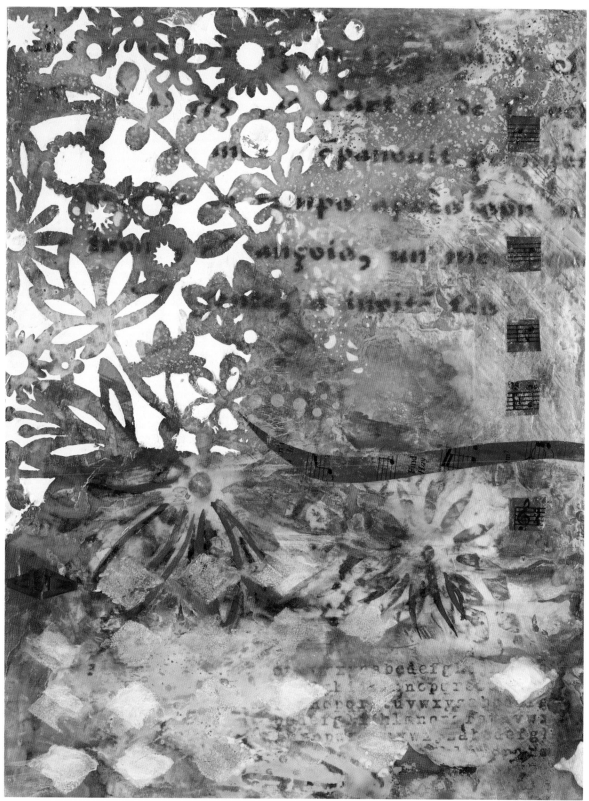

Flowers Forever
12" × 9" (30cm × 23cm)

Materials list

MEDIUMS
heavy gel matte

PAINTS
Copper spray paint, paint pen

MISC.
collage materials, old painting, stencils

36. **Instant** Layers

Instant layers are created when you work over an old painting. I have many panels in my studio that have layers of demos on them. Sometimes they reach a point where they have some interesting texture and colors, and they make a great foundation for a faux encaustic painting.

1 Spray Paint Through a Stencil
Apply Copper spray paint through a stencil over an old painting and let it dry.

2 Apply Gel and Paint Through a Stencil
Apply heavy gel matte mixed with white paint through a stencil. This will add white to a very busy area and create a place for the eye to rest.

3 Apply the Final Touches
Continue to stencil and collage as desired. Work on the painting in layers. Use a paint pen for added effect.

Seal and Reveal

Paint gesso over a busy composition. Let it dry and then sand parts to reveal the background.

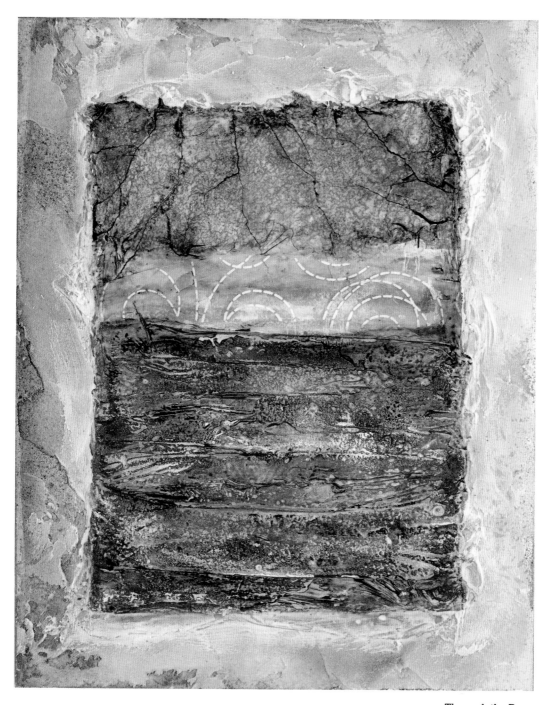

Through the Door
10" × 8" (25cm × 20cm)

Materials list

MEDIUMS
extra-heavy gel molding paste, heavy gel

PAINTS
Azurite Hue, Iridescent Bronze, Payne's Gray, Quinacridone Gold, shimmer white spray mist by DecoART, violet, white

MISC.
Aves ClayShay, craft stick, Elmer's glue, mixing cups, panel, paper, plastic, plastic wrap, spray bottle

Experiment
- Experiment with fiber paste or molding paste applied on top of the dry paper clay.
- See what happens when you mix some colored paper pulp into the clay and glue mixture.

37. **Off** the Canvas

Time to take the painting off the canvas and onto clay and paper. I explored this in *Alternative Art Surfaces*, but I wanted to add some layers to it since it's so much fun, and it really looks like wax. ClayShay will be layered onto paper and then mounted onto a panel. A few collage layers and a topping of gels will complete the waxy look.

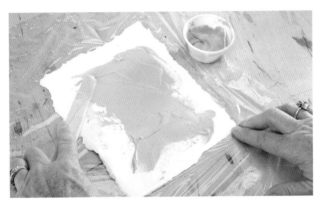

1 Create and Spread the Clay
Mix ClayShay with glue in a 1:1 ratio. Add a small amount of water and stir it into the mix. Spray water onto the paper and rub it so there are no pools and the paper is damp. Place the paper onto a piece of plastic and spread the clay onto the paper.

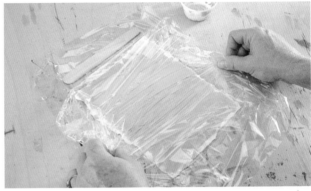

2 Create Marks and Other Texture
While the clay is still damp, use a craft stick to make marks in the clay. Then place plastic wrap over the clay to create texture. Let it dry for a few hours before you remove the plastic wrap.

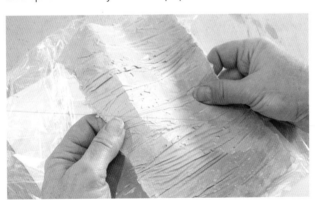

3 Bend the Paper and Let It Dry
As it continues to dry, the paper will curl up. Gently bend back the paper to crack the clay. Let it completely dry. (This may take a day. Check the manufacturer's instructions.)

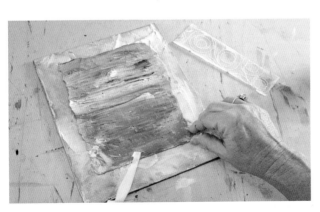

4 Apply Paint Onto the Paper
Paint with Payne's Gray, Azurite Hue, Iridescent Bronze, Quinacridone Gold, violet and white. Apply a shimmer white spray mist over the Payne's Gray paint and let everything dry.

5 Apply the Final Touches
Seal with a combination of heavy gel and extra-heavy gel molding paste. When dry, attach the clay paper to a panel using heavy gel. Weight it and let it dry.

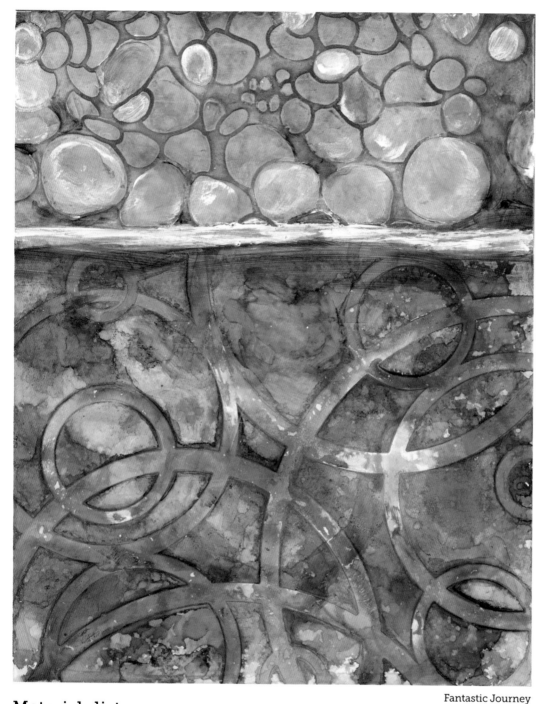

Fantastic Journey
10" × 8" (25cm × 20cm)

Materials list

MEDIUMS
alcohol (or blending alcohol medium), DecoArt Media Antiquing Creams (red and white), fluid matte medium, molding paste

PAINTS
blue, orange, teal, white

MISC.
alcohol inks (blue, brown, green, orange, yellow), Ampersand Claybord, colored pencils, paper towel, satin varnish, spray bottle, stencil

Out With the Old

Use glazes or gel mediums with paint as an alternative to antiquing creams.

38. Alcohol Inks

Wonderful layers are created with alcohol inks applied over stencils onto Claybord. Molding paste applied through stencils adds another dimension. For this project, you'll use watercolor pencils, antiquing creams and paint layers for added depth.

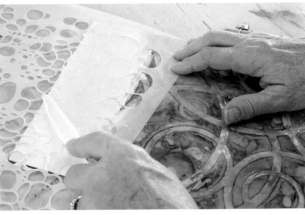

1 Apply Alcohol Inks
Lightly mist the Claybord with water and rub the water into the surface. Place the stencil onto the surface and apply alcohol inks over the stencil. Spritz alcohol or blending alcohol medium and move the alcohol inks around. Let the alcohol inks soak into the Claybord, then remove the stencil and let everything dry.

2 Apply Molding Paste Onto the Claybord
Apply molding paste through the stencil. Remove the stencil and let the molding paste dry.

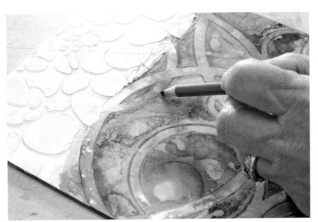

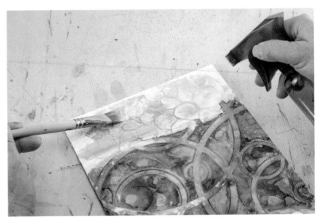

3 Draw With a Colored Pencil
On the ink side, use colored pencil to add shadow. Then blend the lines using matte medium.

4 Apply the Final Touches
Apply watered-down blue, teal, white and orange paint to the molding paste pattern. Let the paints dry and then apply red and white antiquing creams. Use a paper towel to remove as much as you like after the creams have dried. When satisfied, seal with matte medium or varnish and apply another layer. Finish with a satin varnish or faux encaustic medium of your choice.

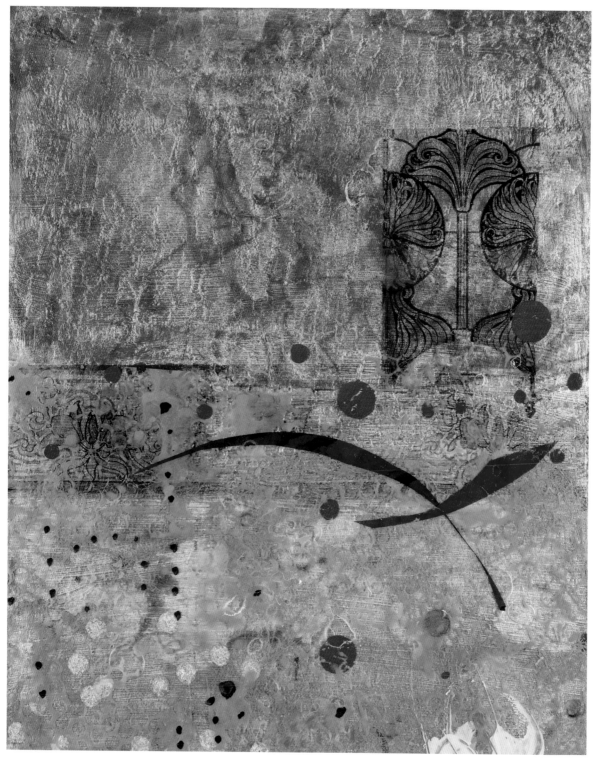

Through the Gate
10" × 8" (25cm × 20cm)

Materials list

MEDIUMS
heavy gel matte

MISC.
candle wax or paraffin, craft stick, disposable gloves, Dura-Lar wet media film, epoxy two-part resin kit, foam brush, laser or ink-jet printer, mixing cups, painted panel, plastic, plastic bin that will cover your painting panel, rice papers or printed papers, scissors, tape

39. **Embed** With Resin

Two-part epoxy resins create a thick, smooth, shiny surface. You can make layers using transparencies or even archival Dura-Lar wet media film. You can print, stamp, paint and write on these transparent surfaces. Then you can paint a panel and start to layer. You need to designate a space where the pieces can be left covered overnight, preferably in a well-ventilated room that can be closed off. I usually do the resin pours in my studio at the end of the day, cover them and leave until the next day. Take precautions as stated on the resin label.

1 Print Onto the Dura-Lar
Paint a panel and print onto the Dura-Lar using a laser printer. Experiment with the layers and background—cut up the transparencies or Dura-Lar and arrange the pieces into a composition. If you're using an ink-jet printer, the Dura-Lar will need to be sprayed with a workable fixative.

2 Apply Tape
Apply tape to the back of the panel and use candle wax or paraffin to rub onto the tape. The resin will run over the edges, and this will make it easier to remove the tape after the resin has dried.

Find Order
Make notes or take a picture so you will remember where the pieces go. I suggest beginning with only a couple of pieces or one to two layers. The resin will move around and change your composition, so be mindful of this.

3 Mix the Resin
Make sure all of the supplies are ready and that you have read and reread the instructions for the resin kit. Place plastic down on your working table and, wearing gloves, place your panel onto three upside-down cups for sturdy elevation. Make sure you have equal parts resin and hardener per the manufacturer's instructions.

4 Pour the Resin
Pour the resin into the hardener and mix, per the instructions on the package.

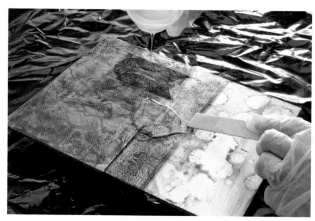

5 Apply the Resin
Apply the resin onto the panel, spreading it across the panel evenly using a foam brush or craft stick.

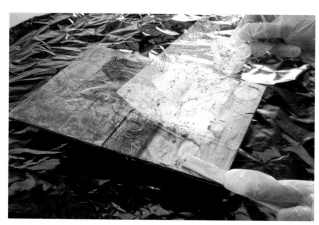

6 Adhere the First Layer
Place the first layer of your Dura-Lar wet media onto the panel.

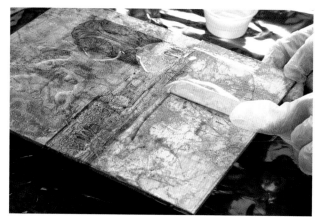

7 Add Another Layer
Apply another layer of resin. Make sure to press out as many air bubbles as possible using a craft stick. Continue this process until all of the papers have been applied to the panel.

8 Create a Collage Layer

Create collage layers by layering rice papers or printed papers with resin.

Step It up a Notch

Use a casting resin and embed objects in the resin.

9 Let the Resin Cure

This step is the opposite of what I do when I want a super smooth and shiny surface. I use the foam brush and drag it across the surface of the wet resin. It will be tacky and you will feel the brush drag. This will create a textured surface that will look like wax. When finished, let it dry and place a plastic bin over it to keep any dust from landing in it. Let it dry and cure according to the resin directions.

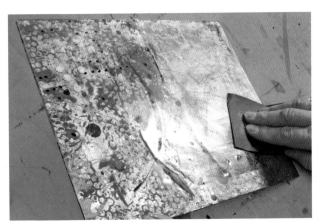

10 Alter the Final Sheen

When the resin has cured, you may alter the final sheen by lightly sanding the panel with fine-grit steel wool or super fine sandpaper.

Dusting

Remove the excess dust with a paper towel sprayed with rubbing alcohol.

11 Apply the Final Touches

Apply a coat of heavy gel matte over the surface of the panel. The resin will create a thick layer like wax, and the gel will give it a satiny look, like wax.

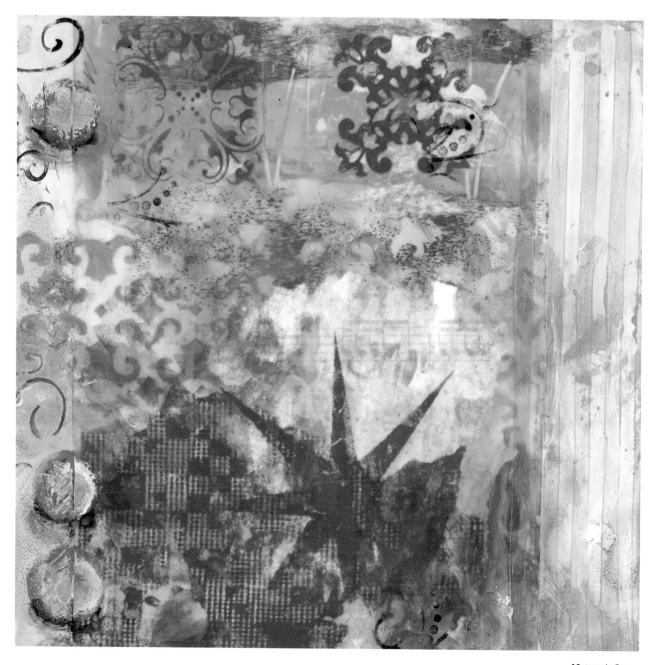

Nature's Song
8" × 8" (20cm × 20cm)

Materials list

MEDIUMS
fluid matte medium, polymer medium gloss, soft gel gloss

PAINTS
your choice

MISC.
Dura-Lar Matte, foam pouncers, ink-jet or laser copy, panel, spray satin varnish, stamps, stencils

Create a Little Mystery...
Leave some of the paper on your transfers. They will create opaque areas.

40. **Dura-Lar** Matte

Dura-Lar Matte by Grafix is a wonderful material that acts like a wax layer. Transfers look fantastic printed on it, and it's great for layering both sides of the translucent material. You can even print on it with a laser or ink-jet printer.

1 Apply Paint and Stamps
Apply paints or stamps to the back side of the Dura-Lar Matte and let it dry. Create some implied textures with alcohol, plastic or water.

2 Transfer the Image Onto the Dura-Lar Matte
Apply either polymer medium gloss or fluid matte medium to the Dura-Lar Matte where you want the image to go. Then lay the ink-jet or laser print copy transfers face down onto the wet polymer. Rub them for about a minute and then pull up the corner to see if the image is staying on the Dura-Lar Matte. If it isn't, put the corner back down and continue rubbing. After you get the first layer of paper off, let it dry. Then spritz your fingers with water and roll off the remainder of the paper until the image appears as desired. The more paper you remove, the more transparent the image will be, but leave some of the paper on for a little variety.

3 Apply Paints, Stamps and Stencils
Use paints, stamps and stencils on both the Dura-Lar Matte and the panel.

4 Apply the Final Touches
Attach the Dura-Lar Matte to the panel using soft gel gloss. Weight down the surface and let it dry. Apply stamps, stencils and pouncers for added effect. Finish with a layer of spray satin varnish.

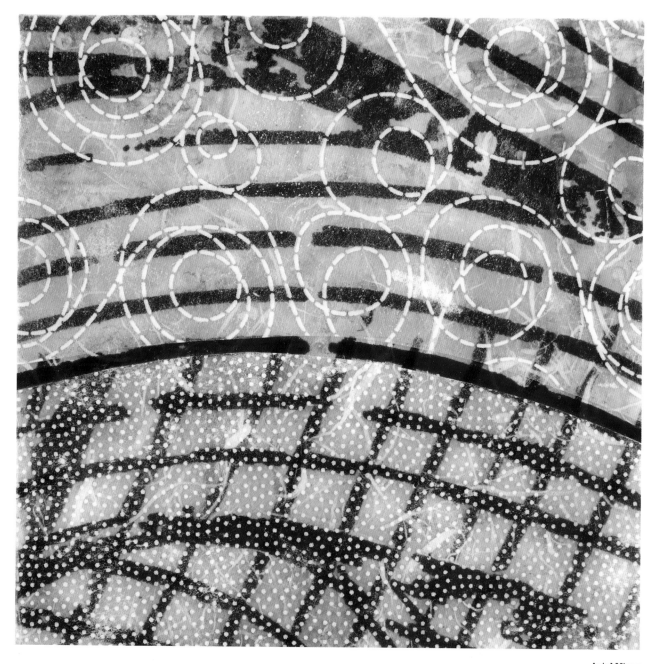

Arial View
6" × 6" (15cm × 15cm)

Materials list

MEDIUMS
DecoArt Triple Thick, fluid matte
medium, spreadable faux encaustic,

MISC.
palette knife, panel, papers (assorted),
plastic, rice papers, scissors

41. Papers

I love paper and all of its wonderful qualities! Rice papers are especially great to layer in collage. A pattern, design or texture will still be apparent when you use acrylic to make the rest of the paper transparent.

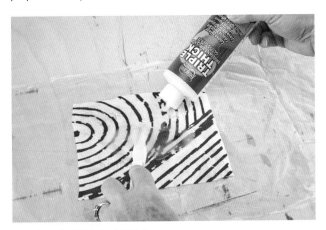

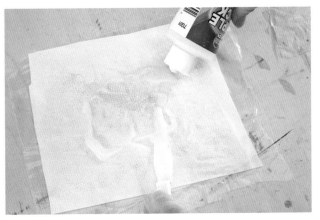

1 Apply Triple Thick
Cut up three different pieces of plastic larger than the size of your paper. Place plastic down on your work surface. Pour Triple Thick onto the different plastic drop cloths and use your knife to spread a thin layer of the medium. Then place the three different rice papers onto the wet Triple Thick. Apply more Triple Thick and carefully spread it with a knife to coat the surface. Don't overwork it, as this product has a natural tendency to level itself. Let it dry so the Triple Thick will turn the rice paper translucent. When the paper is completely dry, peel it off the plastic.

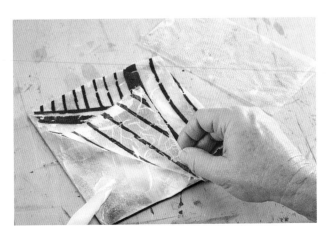

2 Adhere the Rice Papers to a Panel
Glue the papers onto a painted panel using spreadable faux encaustic or fluid matte medium.

3 Apply the Final Touches
Continue layering with other papers and trim sides if needed. Finish and seal with a spreadable faux encaustic.

Paper Patterns

Add interesting elements by using dress patterns, architectural drawings or any other thin papers.

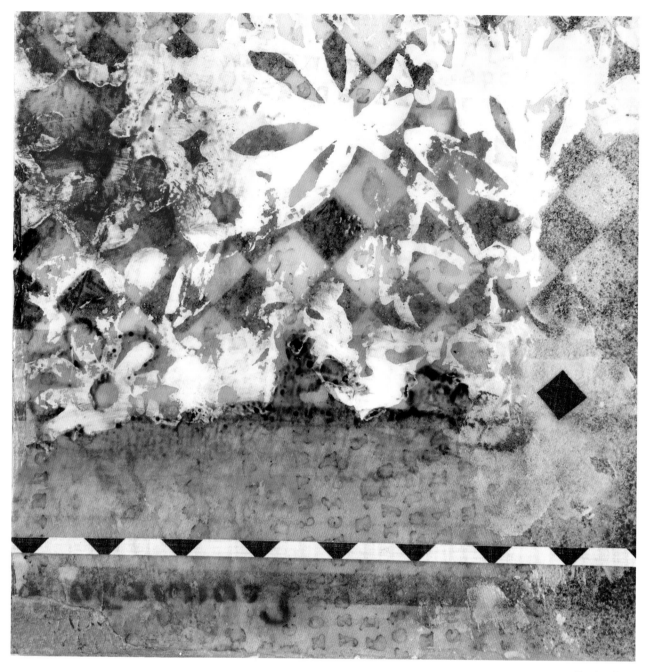

Garden Path
6" × 6" (15cm × 15cm)

Materials list

MEDIUMS
DecoArt Triple Thick, spreadable faux
encaustic

PAINTS
your choice

MISC.
coated rice papers, deli sheets, panel,
papers (assorted)

42. **More** Papers

Painted collage papers are used for this painting. Many of the papers are deli sheets or rice papers that have been used to clean off stencils. This is why I keep all of my leftovers—they're perfect for other projects! This project is not as transparent as the previous one because the papers have been painted.

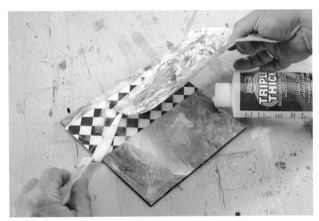

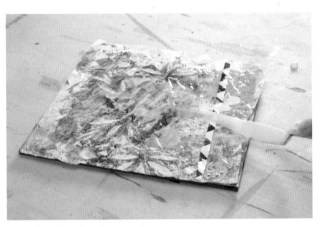

1 **Coat the Rice Papers With Triple Thick**
Paint the background and use Triple Thick to layer the deli sheets, coated rice papers or other bits and pieces. Add paint and more layers.

2 **Apply Final Touches**
Continue collaging or stamping until the piece is finished. Then seal with a spreadable faux encaustic.

More Papers, More Ideas!
- Use a pastel ground to create tooth on which to draw. Spray with a workable fixative and continue layering.
- Used dryer sheets are great for adding texture.

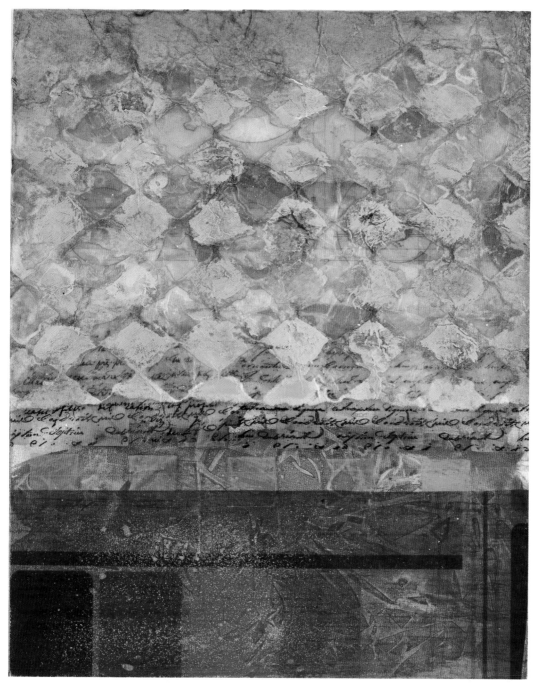

Dancing Veils
10" × 8" (25cm × 20cm)

Materials list

MEDIUMS
matte medium, tar gel

PAINTS
your choice

MISC.
painted background panel, palette
knife, rice paper, stencil

A Little Something More...

This is a great technique to add on top of a
painting that needs a little "something" more.

43. Batik

Batik is done using wax as a resist on fabric and then dying the fabric. The wax is then removed, so it acts as a resist. This project uses acrylic as a resist on paper that is later painted. The batik look comes from using tar gel or string gel on rice paper, then applying washes of color. Mount the paper onto a canvas or panel, and you'll have a waxy-looking painting.

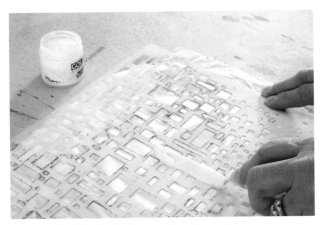

1 Apply Tar Gel Through a Stencil
Use a knife to apply tar gel through a stencil and onto the rice paper. Remove the stencil and let the paper dry.

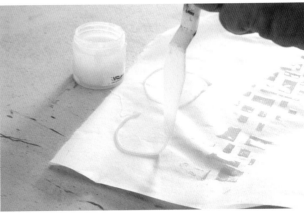

2 Draw or Dribble the Tar Gel
Tar gel has an unique string-like quality that allows you to draw with it. Draw or dribble the tar gel onto the paper and let it dry.

Added Texture
Crinkle the paper before applying the tar gel for additional texture.

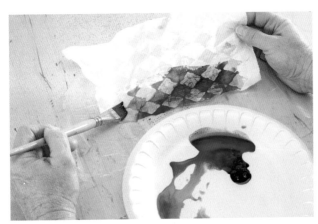

3 Apply Diluted Paint
Crinkle your piece of rice paper and apply diluted paint to the surface, then let it dry. The crinkles will capture more paint and add texture.

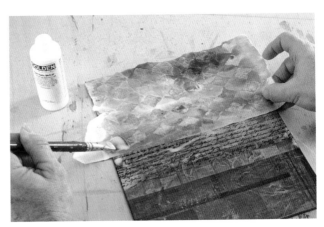

4 Apply the Final Touches
Adhere the rice paper onto a painted background panel using matte medium.

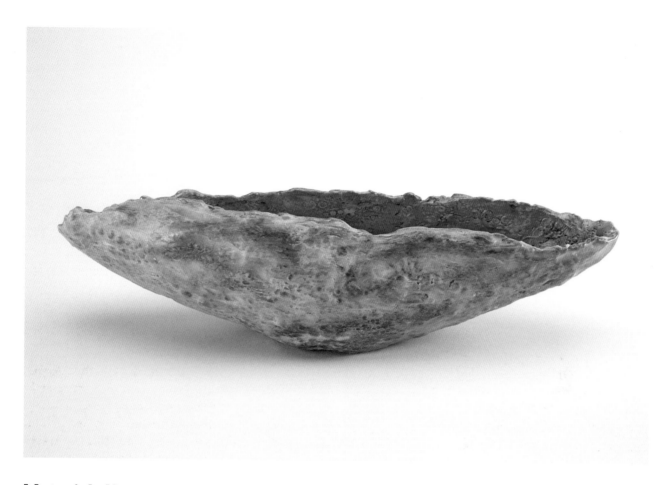

Materials list

MEDIUMS
extra-heavy gel molding paste, heavy gel matte

PAINTS
white, yellow, your choices

MISC.
brayer, found object or bowl (used as a mold), paper clay, plastic wrap, spray bottle, stamp, tape

Boat to Nirvana
3" × 12" × 4" (8cm × 30cm × 10cm)

Other Routes

Use plaster gauze to create the shape and then put a layer of paper clay on top of the dry plaster. Emboss the clay and coat with a faux encaustic of your choice.

44. 3-D Paper Clay

Make a sculpture using clay that air dries and then texture the sculpture and layer on the faux encaustic layers. The result is a lightweight and durable sculpture that looks like it's coated in wax.

1 Flatten the Clay
Cover your mold with plastic wrap and tape it. Make coils from paper clay and place them in between two pieces of plastic wrap. Use a brayer, rolling pin or even your hand to flatten the clay.

2 Form the Mold
Remove the paper clay from the plastic wrap and place it onto the surface of a plastic wrapped bowl. Repeat this step until the entire bowl is covered with strips of clay. Wet your fingers and blend the seams of the separate clay strips, sealing and smoothing the surface of the clay pieces together. Let it dry.

3 Smooth out Cracked Areas
As the clay dries, it may shrink in areas and develop cracks. Mist the clay with water and smooth out any of these cracked areas and add more clay if needed.

Rehyrdate
The paper clay will rehydrate until it is sealed with polymer, so you can continue to work it.

4 Create Patterns and Designs
While the clay is still damp, not wet, gently press a stamp into the surface to create patterns and design elements.

5 Apply Paint
Once the clay has dried completely, paint the sculpture in layers, giving each layer enough time to dry. In the second layer, mix yellow paint with heavy gel matte and rub the mixture over the first dried layer.

6 Add the Final Touches
Apply a thin layer of extra-heavy gel molding paste to seal the sculpture and let it dry. If desired, add paint mixed into more paste to develop the wax effect.

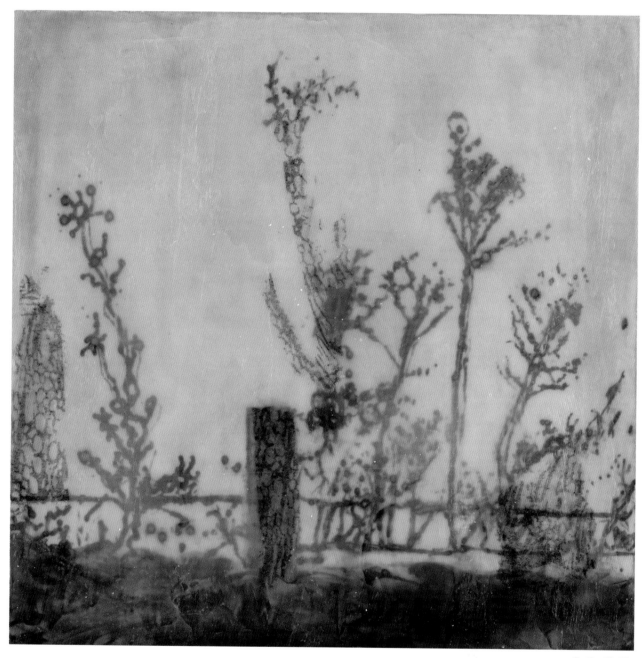

Materials list

MEDIUMS
clear gesso (or acrylic ground for pastels), heavy gel matte

PAINTS
green, Quinacridone Gold, Sepia

MISC.
laser black-and-white print, natural wood panel, wood-burning tools

Freehand
Try the wood burning freehand. This eliminates transferring the image from a laser print.

45. Burn It

Burn it up—the wood that is. I did wood-burning projects when I was a kid so this took me back to my childhood. I coated the finished piece with "wax" that I made with heavy gel matte.

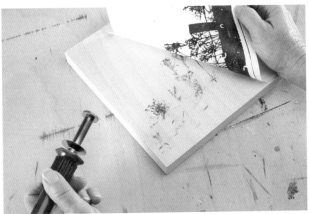

1 Transfer an Image
Select your image and print a black-and-white copy from a laser printer. Tape the laser print onto a natural wood panel, image side down. Attach the transfer tip onto your wood-burning tool and press down over the print to transfer the outline of the image.

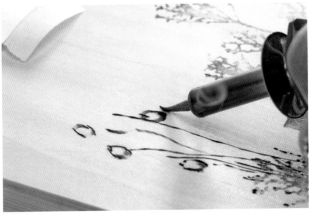

2 Burn the Image Into the Wood
Once the general outline of the image is transferred to the wood, begin burning the image into the wood using alternating tips on the heat tool. (Take precautions with hot tools.)

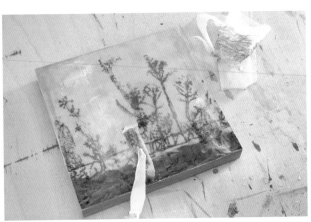

3 Apply Paints
Once the design is burned in, apply diluted clear gesso over the surface (or substitute with diluted acrylic ground for pastel). Apply a layer of watered-down acrylic paints and let it dry. Continue to develop your painting with more paint, but keep the paint transparent.

4 Cover With Heavy Gel Matte
Then cover with heavy gel matte.

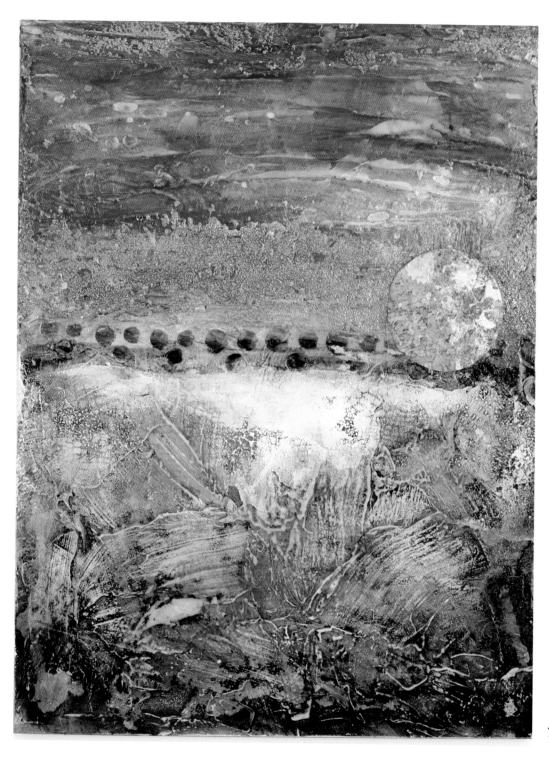

A Wrinkle in Time
12" × 9" (30cm × 23cm)

Materials list

MEDIUMS
glass bead gel, heavy gel matte, light molding paste,
Venetian plaster

PAINTS
Iridescent Gold, red

MISC.
palette knife, panel, sandpaper

46. Mix It Up

This project mixes it up by using several different techniques covered in the book to create a unique surface. You will layer gels, pastes and beads onto your panel. Venetian plaster on deli sheets can be used as collage paper on top of an old painting. Throw in some sanding and glazing with a final finish of paste, and viola! You have depth and sheen.

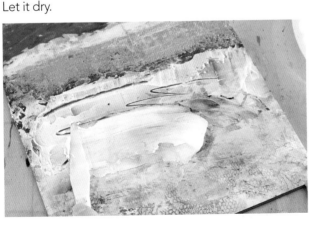

1 Apply Glass Bead Gel
Find a panel that already has a few layers of paint and then apply glass bead gel to a small section of the panel.

2 Apply a Mixture of Paint and Heavy Gel
Apply a mixture of red paint and heavy gel to the surface of the panel above the place you put the glass bead gel. Spread the mixture so that some of the previous background layers show through.

3 Add Light Molding Paste
Add light molding paste to the bottom section to add light and texture. Use the knife to create marks and to let some of the previous layers show through. Let it dry.

4 Paint Over the Dried Glass Bead Gel
Float diluted Iridescent Gold paint over the dried glass bead gel.

5 Apply Final Touches
Apply watered-down paint over the dry light molding paste and add a collage element made from a deli sheet with Venetian plaster. Let the element dry and sand over the lower portion of the panel to reveal texture. Then cover the painting with heavy gel.

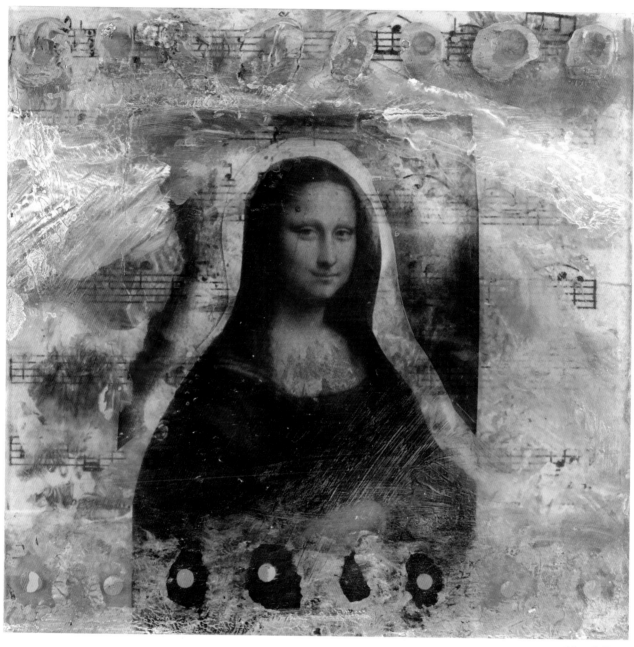

Mona's Song
8" × 8" (20cm × 20cm)

Materials list

MEDIUMS
acrylic wax in white and clear, acrylic wax burnishing, clear flat wax, decoupage (satin or matte), sanded resin, spray varnish, ultra fluid matte medium

MISC.
alcohol, brushes, fine-grit sandpaper (or steel wool), makeup sponge, palette knife, soft cloth

Experiment

Experiment with household chemistry or shop at the local hardware store for products you think may work in your art. Remember layers and sheen are what makes acrylic look like wax.

47. Final Finishes

Creating a waxy-looking painting is all about the layers and the sheen. A lot of techniques were covered for creating both, but there are a few specialty products that can also give the look of wax. Some are only for the final finish but others can be used in layers.

White Acrylic Wax

Apply a thin layer using a makeup sponge. Let it dry, then buff with a soft cloth or dampened paper towel. If this product is applied thicker it becomes white and translucent. Use it to make some areas of your painting more opaque.

Clear acrylic wax may be applied in the same manner—only it's not white. Even though these products are acrylic waxes, I find that when I try to paint on top of this layer with acrylic paint, it does not adhere well. For this reason, I suggest using this for the final layer. *Mona's Song* is a painting on Plexiglas and was finished with acrylic waxes—both clear and white.

Burnishing Wax

Apply this very thinly, either alone or mixed in with paint. Let it dry and then burnish it and buff it to a nice sheen using a soft cloth. This product mixed with paint may be used in layers.

Finding the Goods

Acrylic waxes are sold to faux finishing painters. To make a purchase, look online or at fine house paint stores.

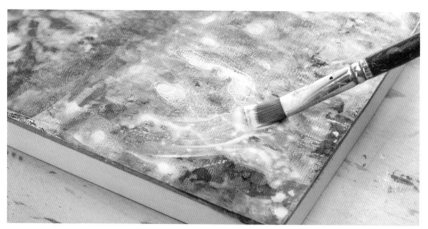

Decoupage Satin or Matte

Brush the decoupage product onto the panel very thinly. Let it dry. You may wish to apply a second coat if shiny areas remain. To apply the second coat, brush in a different direction by turning your painting a quarter rotation.

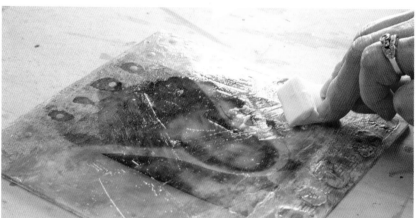

Clear Flat Wax

Apply with a makeup sponge in a very thin layer. Let it dry, then buff with a soft cloth. After you've buffed the surface, apply a second coat if desired. This finish looks the most like wax and has the feel of wax, too.

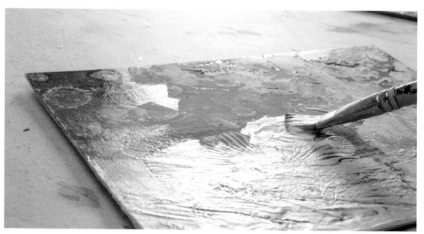

Ultra Fluid Matte Medium

For a more opaque effect, brush on the ultra matte medium thickly. For a more transparent look, apply the medium thinly. This product really diffuses the surface. I recommend trying it on some samples prior to putting it on your painting.

Sanded Resin Decoupage Matte

After your resin layer has fully cured, sand it with a fine-tooth sandpaper or ultra fine steel wool. Wipe the surface clean with a paper towel sprayed with rubbing alcohol. Then apply thin layers of decoupage matte and let it dry.

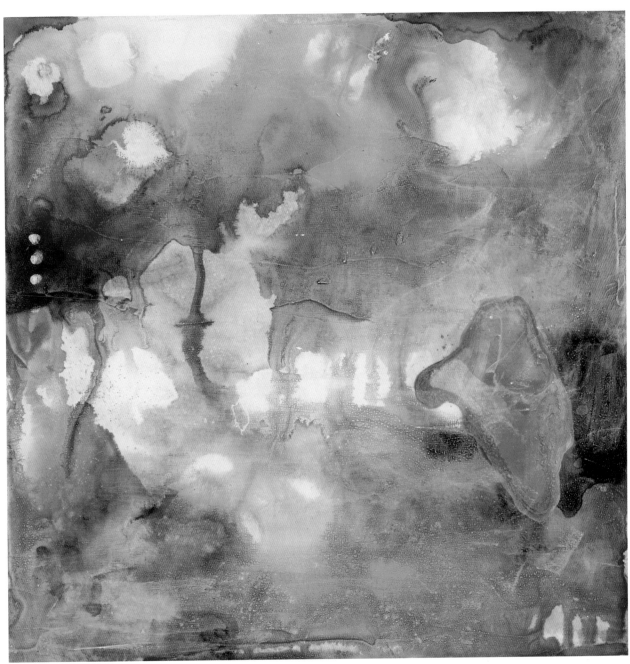

Celestial Flow
12" × 12" (30cm × 30cm)
This piece was finished with both a white and
clear acrylic wax.

Unify a Sheen

Spray varnishes in satin or matte can unify a sheen
and diffuse glossy layers

Index

Metric Conversion Chart		
To convert	To	Multiply by
Inches	Centimeters	2.54
Centimeters	Inches	0.4
Feet	Centimeters	30.5
Centimeters	Feet	0.03
Yards	Meters	0.9
Meters	Yards	1.1

a content + ecommerce company

Other fine North Light Books are available from your favorite bookstore, art supply store or online supplier. Visit our website at fwcommunity.com.

19 18 17 16 15 5 4 3 2 1

DISTRIBUTED IN CANADA BY FRASER DIRECT
100 Armstrong Avenue
Georgetown, ON, Canada L7G 5S4
Tel: (905) 877-4411

DISTRIBUTED IN THE U.K. AND EUROPE
BY F&W MEDIA INTERNATIONAL LTD
Brunel House, Forde Close, Newton Abbot, TQ12 4PU, UK
Tel: (+44) 1626 323200, Fax: (+44) 1626 323319
Email: enquiries@fwmedia.com

DISTRIBUTED IN AUSTRALIA BY CAPRICORN LINK
P.O. Box 704, S. Windsor NSW, 2756 Australia
Tel: (02) 4560-1600; Fax: (02) 4577 5288
Email: books@capricornlink.com.au

ISBN 13: 978-1-4403-4002-4

Edited by Brittany VanSnepson
Cover designed by Hannah Bailey
Interior designed by Rob Warnick and Jamie Olson
Production coordinated by Jennifer Bass

Acknowledgments

The F+W team: To Brittany VanSnepson, my wonderfully intelligent and brightly funny editor. To Christine Polomsky, you always make everything look groovy, and have me laughing and rolling. Remember girls, it's all about the "layers." Kristy Conlin, thanks for all the fun and I look forward to more co-starring moments with you. To my longtime friends at North Light, Jamie Markle, friend and head honcho, Tonia Jenny, friend, editor and fellow artist, and all the other fabulous folks who have made this book a blast to create. I'll see you all again soon.

The Ampersand Art Panel Team: To Elaine Salazar, thank you for all of your inspiration. Who knew that an email regarding a product would turn into such a great relationship? Thank you for not only running a wonderful company but being an incredible woman. Thank you Dana Brown for answering all my technical questions and helping me get the panels out there for people to use. The Ampersand team has contributed so much to the making of this book.

Thank you to Rosemary Reynolds, the Helping Artist Coordinator for DecoArt. Your products were so much fun to experiment with.

Thank you to Hayley at Grafix Arts for introducing me to the Dura-lar that is featured in several chapters.

A big thank you to Dana Simmons, my intern extraordinaire and friend. Your help was priceless.

Dedication

To Mark: Your intelligence, creativity, and patience inspire me to be my best. I would not be able to do what I do without you by my side. I cherish all of our collaborations.

To my Mom: For always believing in me even when I was going the wrong way, and you were still there when I came around.

To Matt and Scott: You are the next generation of explorers-follow your wildest dreams.

About the Author

Sandra Duran Wilson is an abstract American painter based in Santa Fe New Mexico, but has roots as a third generation artist in Mexico, Spain and Italy. She comes from a family of artists and scientists and she combines her background in both fields to express her style of painting largely-abstract stories. She will use imagery from scanning electron microscopes, textured surfaces and acrylic paints and mediums. She also has synesthesia, a crossing of the senses, where music has colors and numbers have sounds. It appears in her work as formulas and musical scores

Sandra has been painting professionally for more than twenty years and her work is represented in many public and private collections including a painting in the permanent collection of the City of Santa Fe Convention Center. She is also represented in corporate offices in New York, Houston, and Pennsylvania. She shares her knowledge through teaching workshops, writing and creating DVDs. She received her Bachelor of Fine Art and her Bachelor of Science from the University of New Mexico. She has lived in Santa Fe NM for over thirty years. Her work is continually evolving and growing as she explores the edges of material science. Her current work in cast acrylic is breaking free from the wall and becoming 3-D painted sculptures.

A Little More…

When creating, my first question is, what if…? This is how I have lived my life and created my art. From the time I climbed onto the back of an old appaloosa horse at the age of 3 and rode off into the sunset, until jumping into a brand new sculpture project for my gallery while in the midst of writing this book; life happens. My Mom had to drive over to the neighbor's ranch to retrieve me; and I am almost ready for my exhibition as I finish writing this. I keep asking myself what if?

Whether I am looking through a telescope and imaging distant galaxies or looking through a microscope and painting the abstract imagery before my eyes, I am always thinking what if… Like what would happen if I combined this with that or tried this material over that? Where someone sees a pile of sticks, I see sculpture material. Life is so entertaining.

Ideas. Instruction. Inspiration.

Receive FREE downloadable bonus materials when you sign up for our free newsletter at CreateMixedMedia.com.

ACRYLIC MEDIUMS
ENCAUSTIC EFFECTS

with SANDRA DURAN WILSON and KRISTY CONLIN

NORTH LIGHT DVD | an artistsnetwork.tv production

ALTERNATIVE ART SURFACES

MIXED MEDIA TECHNIQUES FOR PAINTING ON MORE THAN **35** DIFFERENT SURFACES

Darlene Olivia McElroy & Sandra Duran **Wilson**

5 BOOK SCULPTURES THAT DAZZLE p. 82

COLLABORATE! 8 TIPS FOR MAKING ART WITH FRIENDS p. 32

cloth·paper scissors® COLLAGE MIXED MEDIA ARTISTIC DISCOVERY

WEAR your **art**

get paint on your APRON p. 68

make jewelry WITH FIBER, METAL, WOOD p. 87

Find the latest issues of *Cloth Paper Scissors* on newsstands, or visit ClothPaperScissors.com.

These ... Light ... at you... retaile... suppl... Creat...

w CreateMixedMedia.com for ...test news, free wallpapers, ...demos and chances to win ... BOOKS!

Get your

Visit **CreateMixedMe**... up-to-date information... North Light competiti...

INCITE 3
The Art of Storytelling
THE BEST OF MIXED MEDIA

edited by TONIA JENNY

Introduction

What is it that everyone loves about the look of encaustic painting? Is it the satiny sheen, the luminous layers, the veiled mystery? Yes, so why not wax? I love the look of encaustic paintings, but I am not fond of the fumes or the heat. I have worked in encaustic and I really love encaustic printmaking, but when it comes to painting, I love my acrylics. My painting style lends itself to the look of encaustic because I paint in many thin layers. I am frequently asked if my paintings are encaustic, so I thought I would share what I do with you so you too can get the look. I have developed over 45 techniques that can be used to achieve an encaustic effect using acrylics, and you won't need special tools, equipment or paints.

Faux encaustic is not faster or easier than wax. In fact, it is a bit more time consuming, but I find that I have more options and possibilities. The first and most important process for faux encaustic is understanding viscosity, transparency, then the layers and the sheen or luminosity. Also, there are many great acrylic techniques that are not possible with wax. And yes, there are techniques you can get with wax that you can't with acrylics, but I will show you ways to get similar effects.

It's all about building layers that are partially veiled to create great depth, history and mystery. These techniques may be adapted to whatever your painting style may be: landscape, portrait, still life, surreal or abstract. Some of the techniques here may look familiar from some of my previous books. This book is different in that it isn't just a compendium of techniques but a way of developing a painting. Each chapter is like a project in that you can either follow it from start to finish, exactly like I have, or you can use the concepts to develop your own painting using your own style. Enjoy, experiment and share what you discover.

Happy Layering,
Sandra

Time Flies
10" × 8" (25cm × 20cm)

What You Need

MEDIUMS

There are so many different gels, pastes and mediums out there that it can be a bit confusing. I hope to introduce you to many of the different ones and some of the applications they have. You will see from my formulas that you can substitute different gels and mediums to achieve similar effects. I tend to use Golden products because I am familiar with their properties. You may substitute other brands, just be aware that they are sometimes called by different names and not all have the same properties. I also use Liquitex, Matisse, DecoArt and TriArt. Here is a short list of my go-to mediums.

- Soft gel gloss
- Molding paste
- Light molding paste
- Polymer medium gloss
- Fluid matte medium

PAINTS

The paints I used are listed in each chapter. I like to use many different paint brands, but I almost always use a soft body or fluid paint. If you only have heavy body paints you may still use them, you will just need to dilute them with a small amount of water or polymer medium. Some of my favorite colors are:

- Quinacridone: Gold, Magenta, Burnt Orange
- Phthalo: Turquoise, Green, Blue
- Dioxazine Purple
- Teal
- Sepia
- Metallic
- Payne's Gray
- Yellow Ochre
- Pyrrole: Red, Orange

PAINTING SURFACES

For most of the paintings in this book I have used Ampersand panels. Each chapter will specify what type of surface the panel had: gessobord, claybord, encausticbord or aquabord. Other panels may be substituted with varying results. Some of these techniques may also be done on canvas, paper or fabric.

MISC.

There are so many things that artists find to use in ways they were never intended. Hardware stores and kitchen supply stores are two of my favorite art supply stores. I do shop at art supply stores and specialty painting stores too. Here is a short list of some of the products you will find used in this book. Again, check each chapter for a complete list of materials needed.

- Gold leaf
- Cheescloth
- Crackle paste
- Deli sheets
- Stayz-On ink
- Elmer's glue
- Sandpaper
- Plastic drop cloth
- Fusible webbing

*See each chapter for a complete listing.

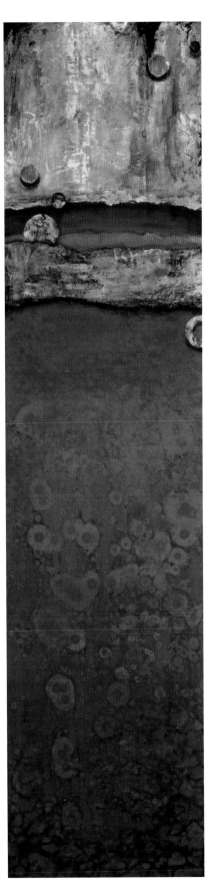

Contemplation
48" × 12" (122cm × 30cm)

Contents

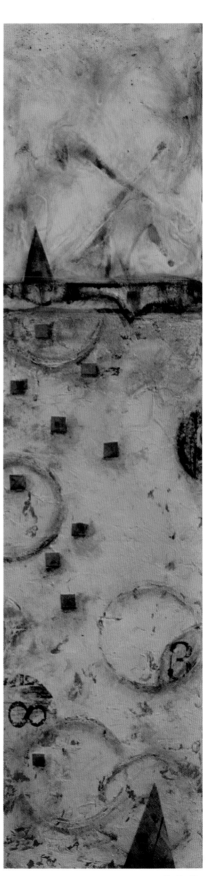

Infinity
24" × 6" (61cm × 15cm)

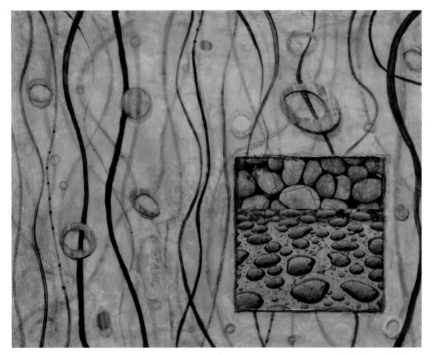

Rocks and Drops
16" × 20" (41cm × 51cm)

ACRYLIC
PAINTING
FOR
ENCAUSTIC
EFFECTS

Sandra Duran Wilson

NORTH LIGHT BOOKS
CINCINNATI, OHIO
www.CreateMixedMedia.com

D1294129